G000065627

PORTOBELLO

MAURICE CURTIS

The History Press Ireland

First published 2012

The History Press Ireland
119 Lower Baggot Street
Dublin 2
Ireland
www.thehistorypress.ie

© Maurice Curtis, 2012

British Library Cataloguing in Publication Data.
A catalogue record for this book is available from the British Library.

ISBN 978 1 84588 737 7

Typesetting and origination by The History Press
Printed in Great Britain

CONTENTS

ACKNOWLEDGEMENTS

Many thanks to Dublin City Libraries and Archives, and in particular the staff of Rathmines and Kevin Street Public Libraries, as well as those of the Gilbert Library. The National Library of Ireland, the Dublin Photographic Archives, the Royal Society of Antiquaries of Ireland, the Irish Georgian Society, the Irish Architectural Archive, Heritage Ireland, Waterways Ireland, An Taisce, the Irish Jewish Museum, the OPW, Flickr, the Irish Historical Picture Company, and the Irish Film Archive were all of particular help.

Dublin City Council and in particular its Dublin.ie/Portobello forum was a great help. The Portobello Historical Society was a fountain of information. Also, that wonderful local historian, 'Damntheweather' of the Dublin.ie forum; his reminiscences and willingness to be of assistance proved to be indispensable. Truly a latter-day saint!

The National Archives has an unrivalled collection of material. RTÉ Stills Library has some wonderful photos, as does the Gilbert Library in Pearse Street. The Lawrence Collection in the National Library, which shows the character of Irish towns and villages from around 1880 to 1910, was unique and valuable. Thanks again to MC Photo Link, Whyte's, Adam's, and MC's FotoFinish who were excellent at retrieving long-forgotten photographs.

Fr Gerard Deighan and the parish council of St Kevin's Catholic church, Harrington Street were very helpful. Particular thanks also to Ronan

Colgan of The History Press Ireland for his great encouragement for this work. And still with the History Press, Beth Amphlett's infinite patience can only mean that she is lined up for sainthood! Likewise to June O'Reilly of the Business Depot in Harold's Cross for her skills, patience and endurance.

Councillor Mary Freehill is a source of much confidence and encouragement. Her boundless energy and commitment to the area for very many years has to be recognised and appreciated. Her pro-active stance on so many issues is widely recognised by the residents of Portobello, Rathmines, Harold's Cross and the surrounding area. For this we are particularly grateful.

Grateful thanks also to Matt Hackett of Clanbrassil Street for some old photographs and likewise to Sean Lynch and Holly O'Brien for their outstanding research charting the history of this street. I am indebted to Ray Rivlin for her *Jewish Ireland: A Social History*. The Bird family in South Richmond Street deserve a particular thanks for keeping their landmark business going strong after all these years.

Thanks also to those stalwarts, Mahmoud Rahim, Thomás Hackett and Derot Dunne of the Café Leonard 'History, Politics and Science Forum' (HPS) for their great appreciation of life and legend in the area. And not forgetting Eddie Rice for his interesting Portobello Barracks photographs.

Finally, a very special thanks to Mercedes and Leesha.

INTRODUCTION

Portobello (in Irish *Cuan Aoibhinn*, meaning beautiful harbour) in Dublin is an area stretching westwards from South Richmond Street as far as Upper Clanbrassil Street, bordered on the north by the South Circular Road and on the south by the Grand Canal. However, over the years, adjacent areas have also been included and, for this book, we are happy to go along with that.

Portobello came into existence in the eighteenth century as a small suburb south of the city of Dublin centred around Richmond Street. During the following century, it was completely developed, transforming an area of private estates and farmland into solid Victorian red-bricked living quarters for the middle classes (on the larger streets), and terraced housing bordering the Grand Canal for the working classes.

As a fast-expanding suburb during the nineteenth-century, Portobello attracted many upwardly mobile families whose members went on to play important roles in politics, the arts and the sciences. Towards the end of the century there was an influx of Jewish people, refugees from pogroms in Eastern Europe, which gave the name 'Little Jerusalem' to the area.

It is in the postal district of Dublin 8 and it is in the local government electoral area of Dublin South East Inner City and the Dáil Constituency of Dublin South East.

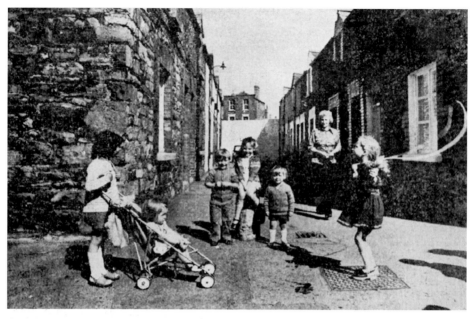

Skipping in Fumbally Lane, off Clanbrassil Street, 1975. (Courtesy of 'Clanbrassil Street 1' by Sean Lynch and Holly O'Brien. Ken Lawford/Paul Harris/The Irish Times)

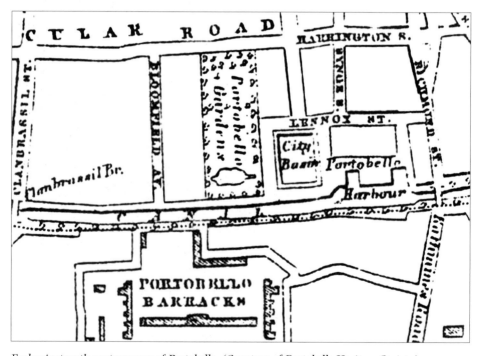

Early nineteenth-century map of Portobello. (Courtesy of Portobello Heritage Society)

A Walking Tour

Let us first follow in the footsteps of famous Dubliners in an excursion around this unique part of Dublin City.* Our walk starts at Portobello College on South Richmond Street, just beside Portobello Bridge or officially La Touche Bridge. This building was originally a hotel on the Grand Canal when it was a busy network from Dublin to the River Shannon. Jack B. Yeats, the famous Irish impressionistic painter, lived there from 1950 till his death in 1957, when the Portobello Hotel had become a nursing home. Turn right into Richmond Row and left at the end to Lennox Street. No. 6 Lennox Street was the home of John McCann, a playwright and Lord

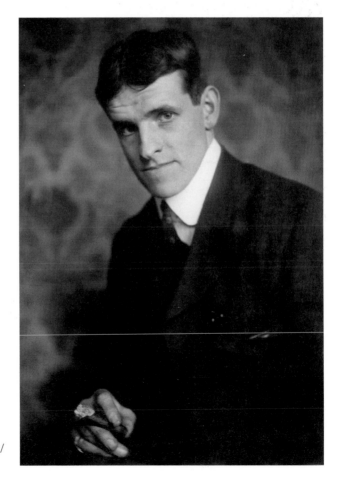

Jack B. Yeats (1870-1957), Irish impressionist painter. and brother of poet William Butler Yeats. He spent his last years in the Portobello Nursing Home (Portobello College) overlooking the Grand Canal, where he painted his final sketch. (Courtesy of Hulton Archive/ Getty Images)

George Bernard Shaw was born at 33 Synge Street. His works include Pygmalion *which was later made into the musical* My Fair Lady, Man and Superman, *and* John Bull's Other Island. *He received the Nobel Prize for Literature in 1925 after the success of his play* Saint Joan, *and the Academy Award for Best Screenplay for* Pygmalion *in 1938. Shaw died while pruning an apple tree at Ayot St Lawrence, Hertfordshire, England, on 2 November 1950. (Courtesy of Portobello Heritage Society)*

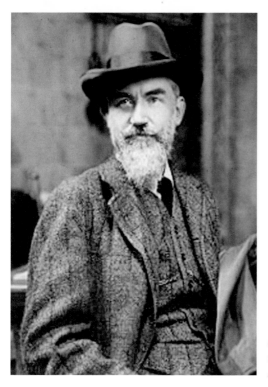

G.B. Shaw in his earlier years photographed by the press. (Courtesy of Portobello Historical Society)

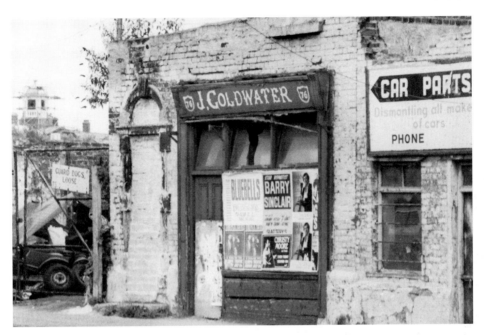

The butcher's shop on Clanbrassil Street in 1984 which was once owned by Janie and Isaac Goldwater. (Courtesy of Ray Rivlin, Jewish Ireland: A Social History*)*

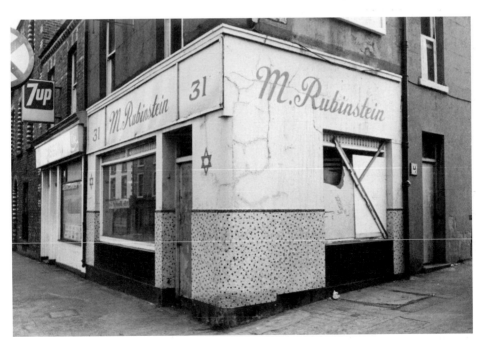

Rubinstein's butcher's shop in Clanbrassil Street after closure in 1980. (Courtesy of 'Clanbrassil Street 1' by Sean Lynch & Holly O'Brien)

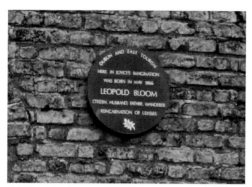

Leopold Bloom, the Jewish character at the heart of James Joyce's novel Ulysses, *was born at 52 Clanbrassil Street. Today, a plaque, unveiled during the Bloomsday celebrations in 1982, commemorates this. (Courtesy of 'Clanbrassil Street 1' by Sean Lynch & Holly O'Brien)*

Mayor of Dublin. No. 28 was the home of famous Irish sculptor John Hughes, whose statue of Queen Victoria was transported to Australia, after Irish independence was won.

We next turn right into Synge Street and at No. 33 we find the birthplace of one of the great names of Irish letters, George Bernard Shaw. Shaw spent the earlier part of his life here, and his experiences in this modest middle-class home were to make an indelible imprint on his literary work. Shaw was awarded the Nobel Prize for Literature in 1925 for his play, *Saint Joan.* In 1993, the house was restored in all its Victorian glory and now houses the Shaw Museum.

Heading back up Lennox Street, turn left up Kingsland Avenue and right into Walworth Road. At No. 4 we find the Jewish Museum, which charts the history of the Jewish community in Ireland. Part of this area was known as Little Jerusalem. No. 1 is the birthplace of famous Irish actor, Barry Fitzgerald (and his brother Arthur Shields) who made his debut in Hollywood at the age of forty-nine. Fitzgerald appeared in such memorable films as *How Green is my Valley* and *The Quiet Man* with John Wayne and Maureen O'Hara.

Turn left into Victoria Street and a right into St Kevin's Road and you will find Bloomfield Avenue. A right turn will bring you to No. 33, the home of Ireland's first Chief Rabbi, Isaac Herzog and his son Chaim Herzog, former President of Israel.

Continue to the end of the street, turning left onto the South Circular Road. Proceed to the junction called Leonard's Corner and just around the corner on No. 52 Upper Clanbrassil Street, you will see a plaque for

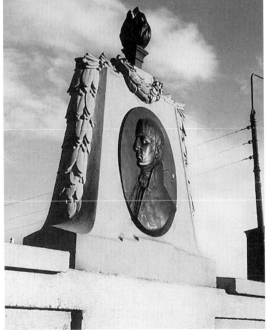

Emmet Bridge (above) is named after Robert Emmet (1778-1803) (left), an Irish nationalist rebel leader. He led an abortive rebellion against British rule in 1803, and was captured in a house near the bridge where he used to lodge. (Courtesy of 'Clanbrassil Street 1' by Sean Lynch & Holly O'Brien)

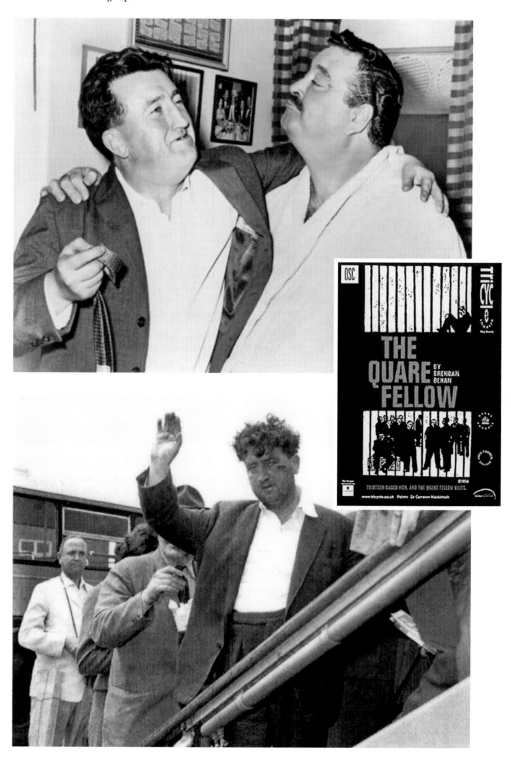

Opposite, from top:

Irish author Brendan Behan in convivial form with American comedian Jackie Gleason in the 1950s. The Quare Fellow was Behan's first play, produced in 1954. The play is set in Mountjoy Prison, Dublin. In 1962 the play was adapted for the screen by Arthur Dreifuss and starred Patrick McGoohan, Sylvia Syms and Walter Macken. Some of the scenes were filmed at Upper Clanbrassil Street/Emmet Bridge. In the film, and to the music of 'The Auld Triangle' song, the camera sweeps over the wet cobblestones of the bridge and over the Grand Canal. (Courtesy of Portobello Heritage Society)

A 1956 Playbill for The Quare Fellow. *(Courtesy of Portobello Heritage Society)*

The famous writer Brendan Behan waving goodbye. Scenes from the film version of The Quare Fellow *were shot at Clanbrassil Street. (Courtesy of Dublin.ie Forums/Dan1919Breen)*

Leopold Bloom as it was here that he was said to have lived in James Joyce's *Ulysses*. The bridge you see before you, Robert Emmet Bridge, (in honour of that great Irish patriot) was immortalised in a film version of Brendan Behan's *The Quare Fellow* and, just around the corner on Windsor Terrace we have Lock's restaurant, where scenes from Christy Brown's *My Left Foot* were shot. (Long before it became a restaurant, it was a sweet shop and the basement which is now a wine cellar, was used as a look-out post for War of Independence volunteers because it was directly opposite the entrance to Portobello Barracks just across the Grand Canal.)

Now retrace your steps back to the South Circular Road, heading towards Camden Street. On the way, to your left, you will pass 30 Emorville Avenue where James Joyce's parents stayed at in 1881, before moving to Rathgar where James was born the following year. So it would appear that James Joyce was conceived in Emorville Avenue! It is not surprising that Portobello areas such as Emorville Square, Lombard Street West and St Kevin's Parade are all mentioned in *Ulysses*.

Keep going until you find Heytesbury Street, again on your left, just before the landmark St Kevin's church with its ornate stained-glass windows. No. 33 was the birthplace of Cornelius Ryan, author of *The Longest Day*, *The Last Battle* and *A Bridge Too Far*. Turn right onto Grantham Street and right again onto Synge Street. Here we find the Synge Street School run by the Christian Brothers foundation with an array of past pupils including TV presenters; Gay Byrne and Eamonn Andrews and actors; Noel Purcell and Cyril Cusack.

An early portrait of James Joyce, Zurich, 1919. (Courtesy of Portobello Heritage Society)

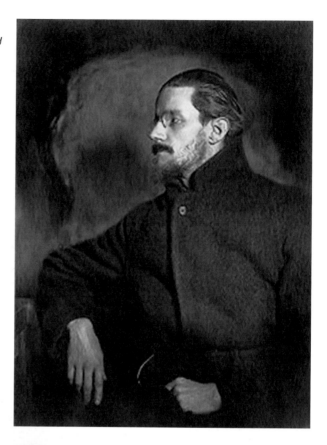

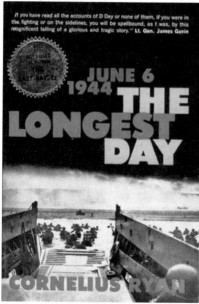

Left: *Cornelius Ryan moved to London in 1940 and became a war correspondent for the* Daily Telegraph *the following year. He initially covered the air war in Europe, flew along on fourteen bombing missions and then joined General George S. Patton's Third Army and covered its actions until the end of the European war. In 1956 he began to write down his Second World War notes for* The Longest Day, *which tells the story of the D Day invasion of Normandy. It was published three years later in 1959 and became an instant success. Ryan also helped in the writing of the screen play for the film of the same name.*

Opposite, from top:

Early photograph of the interior of St Kevin's church, Harrington Street, c. 1910. (Courtesy of the National Library of Ireland)

Another view of the interior of St Kevin's church, c. 1910. (Courtesy of the National Library of Ireland)

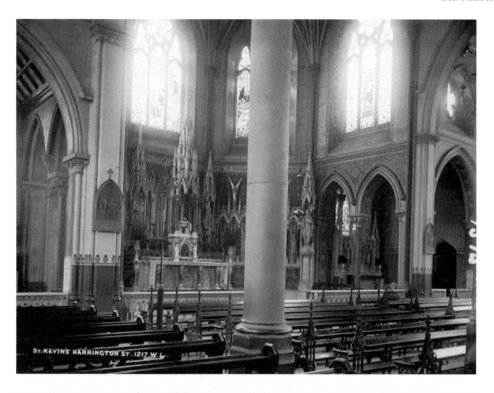

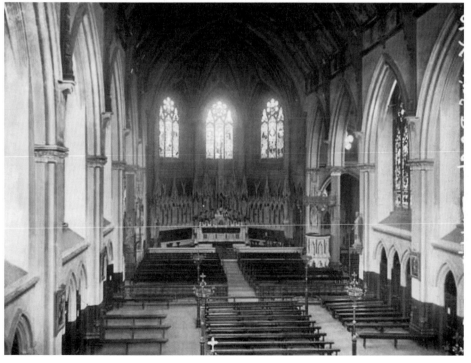

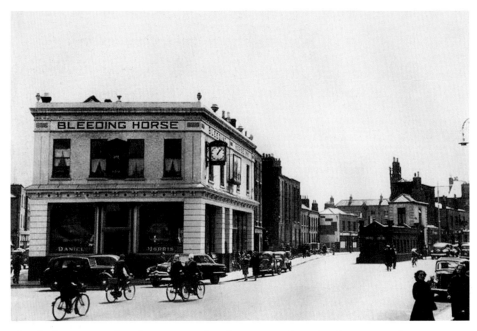

The Bleeding Horse pub in the 1950s with cyclists coming from Camden Street and moving towards South Richmond Street and Portobello Bridge. (Courtesy of Portobello Heritage Society)

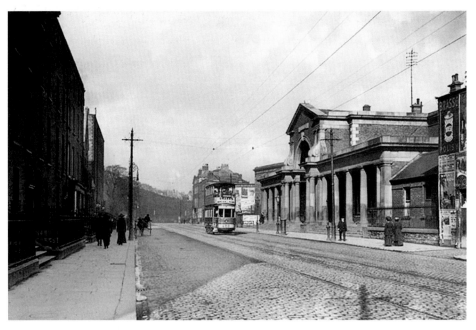

Looking down Harcourt Street, c. 1910. The railway station can be seen to right of tram. (Courtesy of Dublin.ie Forums/Bang Bang/The National Library of Ireland)

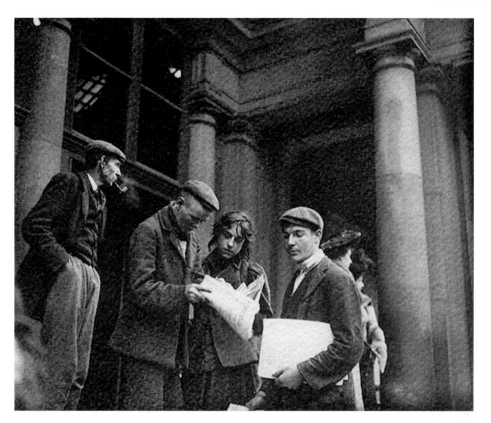

Selling newspapers at Harcourt Street railway station, c. 1900. (Courtesy of the National Library of Ireland)

Turn left onto Grantham Street and left again onto Camden Street. Across the road is the Bleeding Horse pub, which the Irish poet James Clarence Mangan used to frequent. Head up Charlotte Way to Harcourt Street, where you will find a large stone building which used to house the Harcourt Street railway station. As we walk down Harcourt Street we find No. 6, the residence from 1854 of Cardinal John Henry Newman, the first rector of University College Dublin and No. 4, which was the birthplace of Edward Henry Carson, the founder of modern unionism in Northern Ireland.

And finally, if you have any energy left, cut across the top of Harcourt Street, via Adelaide Road, to Harcourt Terrace, and feast your eyes on this unique and tranquil terrace of Regency houses, perpendicular to the Grand

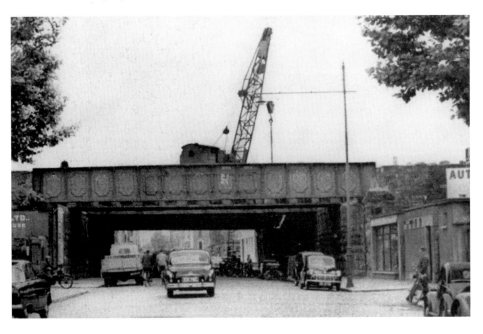

Above: *This photograph was taken in 1959, when they were demolishing Adelaide Road railway bridge leading to Harcourt Street station. (Courtesy of Polito45/Dublin.ie Forums)*

Left: *Harcourt Terrace residents Michael MacLiammoir (left) and Hilton Edwards in a scene from the play* Abdication, *shown at their Gate Theatre, Dublin, 1948. (Courtesy of Life/Nat Farbman/Time & Life Pictures/Getty Images)*

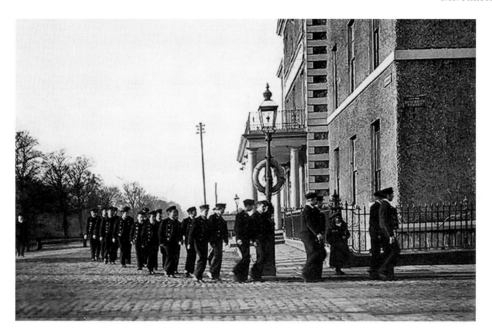

Above: *A group of boys in uniform marching at corner of Portobello Bridge and Richmond Street South, c. 1897-1904. Notice the little girl standing on the kerb, watching, and also the lifebelt on the ornate lamp post. (Courtesy of J.J. Clarke/ National Library of Ireland)*

Right: *A view of Clanbrassil Street/New Street in early 1960s. (Courtesy of 'Clanbrassil Street 1' by Sean Lynch and Holly O'Brien)*

Canal. Here you will find the homes of the Gate Theatre's Hilton Edwards and Micheál Mac Liammóir, that of the artist Sarah Purser, and the house where George Russell's (Æ) first production of his play *Deirdre* was shown. Around the corner, in the shadow of Charlemont Bridge, you will see the monument in honour of writer Paul Smith. Then, you may wet your whistle in the Barge, the Portobello, the Lower Deck, O'Connell's, or the George Bernard Shaw, or even the Bleeding Horse pub, before you pop in to browse in Christy Bird's antique emporium in Richmond Street. And then, depending on your appetite, you might like something tasty from the Aprile café, or just around the corner, an exotic pastry from the Bretzel or a leisurely lunch in The Lennox. All in all, a very promising amble around Dublin's 'Jewel in the Crown', Portobello!

*This passage on the Walking Tour of Portobello was based on the excellent material at the www.dublinlinks.com website, which is well worth a visit.

1

JENKIN'S EAR
AND THE LIBERATOR

The name Portobello describes the stretch of the Grand Canal from Robert Emmet Bridge to the bridge linking South Richmond Street to Rathmines, and from the canal to the South Circular Road area and Camden Street. Although usually referred to as Portobello Bridge, the correct name for this bridge is La Touche Bridge, named after William Digges La Touche, 1747-1803, scion of a prominent Dublin business family and a director of the Grand Canal Company. Like the Portobello area of London, Dublin's Portobello was named after the capture by Admiral Vernon in 1739 of Portobelo, Colón on Panama's Caribbean coast, during the conflict between the United Kingdom and Spain known as the War of Jenkins's Ear. Its unusual name, coined by Thomas Carlyle in 1858, relates to Robert Jenkins, captain of a British merchant ship, who exhibited his severed ear in Parliament following the boarding of his vessel by Spanish coast guards in 1731. This affair and a number of similar incidents sparked a war against the Spanish Empire.

The earliest written accounts we have of residents in the area date from the eighteenth century. As the city spread southwards houses on the main roads or in select by-roads such as Charlemont Mall overlooking the canal, were occupied by the better-off citizens. This trend continued in the first half of the nineteenth century, but with the development of the smaller streets from around 1860 and finally the artisans' dwellings, a mix of

classes ended up in the area. By the beginning of the twentieth century, the grand houses that had been erected along the Grand Canal had been turned into poverty-stricken tenements, while more exclusive suburbs such as Rathmines, Rathgar and Terenure became the havens of the rich.

From Grattan's Parliament to the 1798 Rebellion

Henry Grattan (1746-1820) was a member of the Irish House of Commons and a campaigner for legislative freedom for the Irish Parliament in the late eighteenth century. In 1800, he opposed the Act of Union that merged the Kingdoms of Ireland and Great Britain. He was honoured with the gift of a house and land in Portobello at the end of the eighteenth century by the citizens of Dublin, for his tremendous work for legislative freedom, that culminated in a separate Irish (Grattan's) Parliament of 1782.

Yet another association with Portobello is that of Lord Edward FitzGerald, an Irish aristocrat and revolutionary. He was the fifth son of the 1st Duke of Leinster and the Duchess of Leinster (*née* Lady Emily Lennox). He was born at Carton House, near Dublin and died of wounds received in resisting arrest on charge of treason. Prior to his arrest, he lay concealed in one of the small houses in Martin Street at the back of the Portobello Hotel, following the failure of the 1798 Rebellion.

The Irish Rebellion of 1798 was an uprising lasting several months against British rule in Ireland. The United Irishmen, a republican revolutionary group influenced by the ideas of the American and French revolutions, were the main organising force behind the rebellion. Mr Madden, in his *United Irishmen*, says it was the house of a widow lady of the name of Dillon, to whom Lord Edward was introduced by a Dr Lawless. Lord Edward went by the name of Jameson, but his real name was discovered by means of his boots, on the lining of which his titles were given at full length. The first time he was concealed at Mrs Dillon's he escaped detection, and went away unharmed. He returned in May, when the pursuit after him was becoming very keen. He arrived at Mrs Dillon's, accompanied by his faithful friends Dr Lawless and Cormick, the feather merchant. His clothes

Left: *Henry Grattan of Grattan's Parliament and Irish legislative independence fame. He was awarded a house and land near Portobello Bridge in honour of his sterling work in achieving Irish legislative independence in the late eighteenth century. (Courtesy of Patrick Comerford)*

Below: *The Irish House on Wood Street shortly before its demolition showing a seventeen-figure frieze that depicted Henry Grattan's last appeal in the Irish House of Commons before the passing of the Act of Union in 1800, surrounded by his friends in the Patriot Party (Courtesy of Patrick Comerford)*

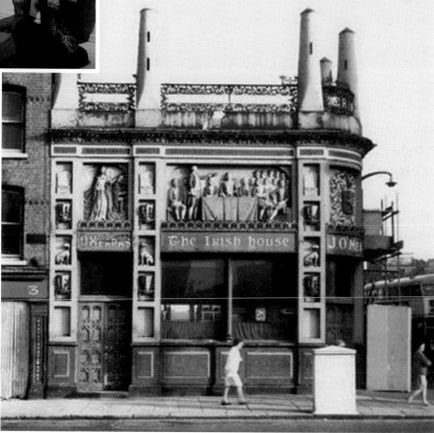

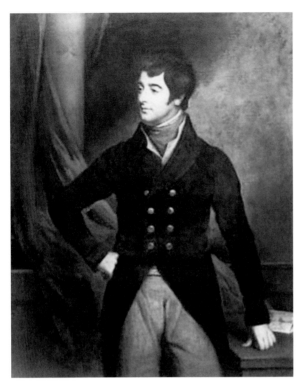

Lord Edward FitzGerald, the Society of United Irishmen leader of 1798 fame, had a hiding place at Portobello harbour, in May 1798, at a house belonging to a widow named Dillon in Martin Street. (Courtesy of Portobello Heritage Society)

were soiled with mud from having lain down in a ditch by the roadside until some people passed.

Moore tells how Mrs Dillon was visiting a neighbour when the news was brought to her that Miss FitzGerald of Ally had arrived. The poor woman was so agitated that she fainted. Lord Edward's unguarded conduct was always a source of great anxiety to his friends. 'He would take no precautions,' says Moore, 'and scarcely a day passed without his having company to dinner.'

He left Mrs Dillon's house on 13 May to proceed with plans for the general rising in Dublin, which was fixed for the 23 May 1798. The tragedy of his arrest and death quickly followed. On 18 May Town Major Henry C. Sirr led a military party to a house in Thomas Street where Lord Edward was in bed suffering from a fever. Alerted by the commotion, he jumped out of bed and, ignoring the pleas of the arresting officers Major Swan and Captain Ryan to surrender peacefully, FitzGerald stabbed Swan and mortally wounded

Ryan with a dagger in a desperate attempt to escape. He was only secured after Sirr shot him in the shoulder and was beaten unconscious by the rifle butts of the soldiers.

He was conveyed to Newgate Prison, Dublin where he was denied proper medical treatment. At the age of thirty-four he died of his wounds as the rebellion raged outside on the 4 June 1798. He was buried the next day in the cemetery of St Werburgh's church, Dublin.

The Bold Robert Emmet

Robert Emmet (1778–1803) was an Irish nationalist, orator and rebel leader born in Dublin. He led a rebellion against British rule in 1803 and was captured, tried and executed for high treason. After the 1798 Rising, Robert Emmet was involved in reorganising the defeated United Irish Society. In April 1799, a warrant was issued for his arrest, and he escaped and soon after travelled to the Continent, in the hope of securing French military aid. His efforts were unsuccessful, and he returned to Ireland in October 1802. In March the following year, he began preparations for another rising. The rising went ahead in Dublin on the evening of 23 July 1803.

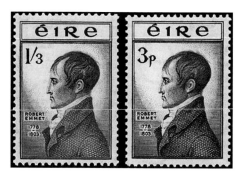 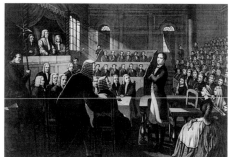

Above left: *Robert Emmet was honoured on two Irish postage stamps issued in 1953, commemorating the 150th anniversary of his death. (Courtesy of Portobello Heritage Society)*

Above right: *The trial of Irish patriot Robert Emmet, 1803. (Courtesy of Portobello Heritage Society)*

Failing to seize Dublin Castle, which was lightly defended, the rising amounted to a large-scale riot in the Thomas Street area. Emmet personally witnessed a dragoon being pulled from his horse and piked to death, the sight of which prompted him to call off the rising to avoid further bloodshed. However, he had lost all control of his followers and in one incident, the Lord Chief Justice of Ireland, Lord Kilwarden, reviled as chief prosecutor of William Orr in 1797, but also the judge who granted habeas corpus to Wolfe Tone in 1798, was dragged from his carriage and hacked to death. Sporadic clashes continued into the night until finally quelled by the military at the estimated cost of twenty military and fifty rebels dead.

'Let No Man Write My Epitaph'

Emmet went into hiding but, on 25 August 1803, he was captured near Clanbrassil Street Bridge. He had been attempting to continue to see his sweetheart, Sarah Curran of Rathfarnham, and in so doing had put his own life at risk. When captured, he had on his person loveletters from Sarah, but he refused to give up her name. On 19 September, Emmet was tried for treason, a trial in which the case of the Crown was assisted by Emmet's own barrister, Leonard Macnally, who agreed to sabotage his own case in return for £200 and the promise of a pension.

Following the judgment, Emmet gave the following speech from the dock, which has since become a classic of Irish oratory:

Let no man write my epitaph; for as no man who knows my motives dare now vindicate them, let not prejudice or ignorance, asperse them. Let them and me rest in obscurity and peace, and my tomb remain uninscribed, and my memory in oblivion, until other times and other men can do justice to my character. When my country takes her place among the nations of the earth, then and not till then, let my epitaph be written.

Clanbrassil Street Bridge was rebuilt and renamed Robert Emmet Bridge in his honour in the 1930s and a bronze plaque commemorating him is set in stone on the bridge itself.

The Great Liberator

The Portobello area was also linked to the successful struggle for Catholic Emancipation (1829) and the subsequent movement for Repeal of the Act of Union (1801). The site of Richmond Gaol on the South Circular Road, near Leonard's Corner, was originally known as Grimswoods Nurseries. The first buildings on the site were those of a Remand Prison or Bridewell. Begun in 1813 by the architect Francis Johnston, it was built to relieve pressure on the Newgate Prison, Dublin. On the re-organisation of the government following Thomas Drummond's appointment in 1835 as Under Secretary for Ireland, it became a male penitentiary. 'Cease to do evil; learn to do well', was the motto over the door of the Richmond Bridewell.

One of the most famous occupants of Richmond Gaol was 'The Liberator', Daniel O'Connell, together with his son John. Once Catholic Emancipation was achieved in 1829, O'Connell campaigned for repeal of the Act of Union, which in 1801 had merged the Parliaments of the Kingdom of Great Britain and the Kingdom of Ireland to form the United Kingdom of Great Britain and Ireland. In order to campaign for Repeal, O'Connell set up the Repeal Association. He argued for the re-creation of an independent Kingdom of Ireland to govern itself. The main weapon of the Association was the 'Monster Meeting', which were held with some 100,000 people in attendance. These meetings were finally banned by the British authorities, and O'Connell complied for fear that there would be bloodshed. The end of meetings, however, spelt the end of the movement, though it did lead to the foundation of the Young Ireland movement in its stead. Daniel O'Connell died in 1847, and was buried in Glasnevin Cemetery.

O'Connell's philosophy and career have inspired leaders all over the world, including Mahatma Gandhi and Martin Luther King. Honoré de

Right: *The Liberator Daniel O'Connell was imprisoned in Griffith Barracks in 1844. (Courtesy of Portobello Heritage Society)*

Below: *The Liberator Daniel O'Connell is honoured on the first commemorative stamps of Ireland, issued in 1929. (Courtesy of Portobello Heritage Society)*

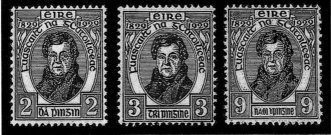

Balzac wrote, 'Napoleon and O'Connell were the only great men the 19th century had ever seen.'

The gaol later became Wellington Barracks, then, with Irish Independence, Griffith Barracks, and is now home to Ireland's largest private college, Griffith College.

The Fenians

Richmond Gaol was also linked to prominent Irish Nationalist leaders such as William Smith O'Brien and Thomas Francis Meagher. James Stephens (founder of the IRB) and 'Honest' Tom Steele, were among its famous historical prisoners.

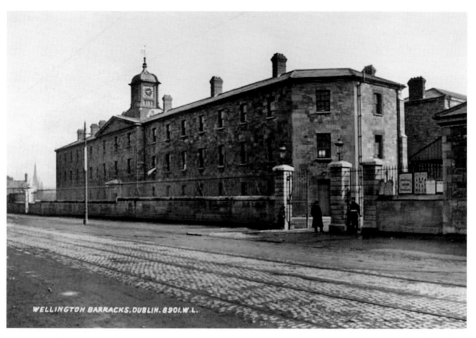

Wellington Barracks/Griffith Barracks, c. 1900. (Courtesy of the National Library of Ireland)

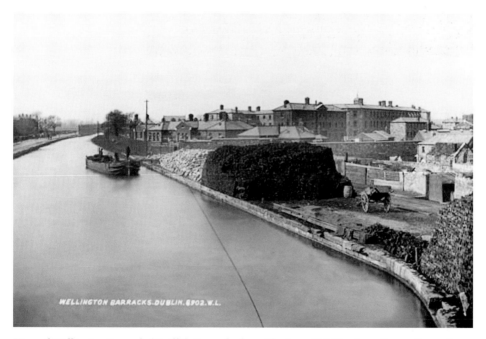

View of Wellington Barracks/Griffith Barracks from Clanbrassil Bridge (now Emmet) over the Grand Canal, c. 1900. Gordon's Fuel Merchants, still trading, can be seen in the foreground. (Courtesy of the National Library of Ireland)

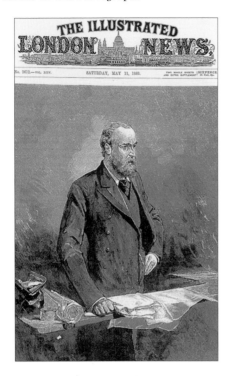

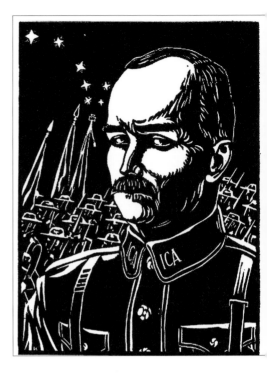

Parnell in the witness box during the Special Commission investigating alleged links between Parnellism and crime. (Courtesy of drawing by R. Taylor, Illustrated London News, 11 May 1889)

A print of Harry Kernoff's woodcut showing Irish 1916 Rising leader, James Connolly. Woodcut shows Connolly with Irish Citizen Army (ICA) behind. Renowned artist Harry Kernoff lived and had his studio in 13 Stamer Street, Portobello. (Courtesy of Peter Geoffrey of Collectibles Corner/ Maurice Curtis)

With the end of the American Civil War in 1865, the Fenian Brotherhood in America sent its most trusted military officer, Captain Thomas Kelly, home to Ireland to assess the prospects for a Rising, and to advise on military matters. By summer 1865, John Devoy was convinced that the time was ripe for a rising. The Fenian chief, James Stephens, was captured in Dublin. However, Kelly, with John Devoy and others, rescued Stephens from Richmond Gaol, much to the consternation of Dublin Castle. Kelly then arranged their harrowing escape from Ireland, via a collier to Kilmarnock in Scotland, thence by rail to London, and from there to Paris and ultimately to America. Another distinguished inmate was the Lord

Mayor of Dublin, Timothy Daniel Sullivan, who was arrested for publishing *The Nation*, an Irish nationalist newspaper, in 1887.

In 1887 the gaol was transferred to the War Department. The additions and extensions were completed by 11 November 1893 but prior to that, in summer 1892, a battalion of the Royal Munster Fusiliers was in occupation. In this era it was known as Wellington Barracks after the Duke of Wellington, an Irishman responsible for the defeat of Napoleon at Waterloo, and whose monument stands in Dublin's Phoenix Park. During the First World War it was used as a recruiting and training centre for many of the Irish soldiers who fought in that war.

The 1860s: Hot Air and Cyanide

Another barracks, on the opposite bank of the Grand Canal and within view of Wellington Barracks is Portobello Barracks, now Cathal Brugha Barracks. It was constructed between 1810 and 1815, and has been in continual use since then. In 1817, William Windham Sadlier successfully flew in a hot air balloon from Portobello Barracks to Holyhead in North Wales.

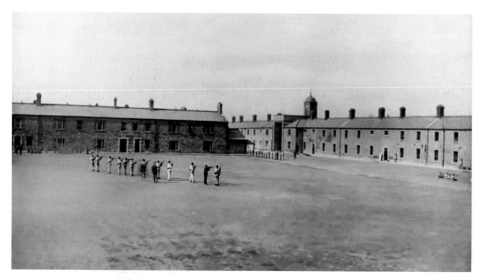

An early picture of Portobello Barracks, c. 1910. (Courtesy of the National Library of Ireland)

In 1867, at the time of the Fenian Uprising, security was stepped up, and an innocent young resident of Bloomfield Avenue, walking his dog in the vicinity, was accused of breaking and entry. He had a hard time explaining away the gun and eighteen bullets he had in his pocket, but he was acquitted of any wrongdoing.

The barracks was the scene of a sensational murder on 27 December 1873, when the body of Gunner Colin Donaldson was found slumped across the bed of Anne Wyndford Marshall, in the apartment she shared with her husband. He had been poisoned with Hydrogen cyanide, which Mrs Marshall had purchased a few days previously. The inquest on 8 January 1874 heard that Donaldson and Marshall had had disagreements on several occasions but ended up on good terms. Although the evidence was stacked against her, at her trial on 10 February the jury found Mrs Marshall not guilty.

The 1916 Rising and the War of Independence

During the Easter Rising in 1916, the Irish Citizen Army sent a group of men to seize a delaying position at Portobello Bridge, to allow fortifications to be constructed in the city centre. They were led by a James Joyce (not the author) who worked in Davy's Bar near the bridge; the bar was to be used as a military outpost. When his unit burst in, Davy, the bar owner, sacked Joyce, giving him one week's notice. Joyce then told Davy he had five minutes to get out!

Murder of Sheehy-Skeffington

During the Easter Rising, members of the British 11th East Surrey Regiment at Portobello Bridge arrested Francis Sheehy-Skeffington on 25 April 1916 for no apparent reason, while he was returning to his home in Rathmines. He was taken to Portobello Barracks, where he was held as an enemy sympathiser. That evening, he was taken out as a hostage with a

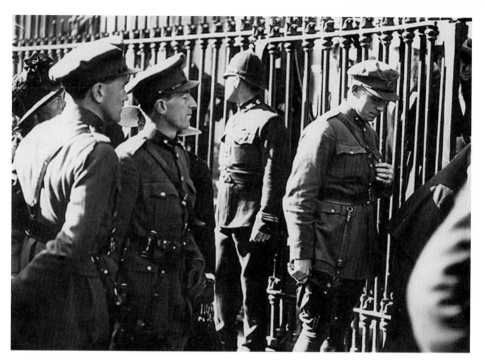

Officers from Portobello Barracks entering the Pro-Cathedral in 1922 for the funeral of General Michael Collins, who was based in Portobello Barracks before his ill-fated journey to Béal Na Blath, where he was ambushed and shot. (Courtesy of the National Library of Ireland)

raiding party led by Captain J.C. Bowen-Colthurst of the Royal Irish Rifles, to the home and shop of alderman James Kelly, at the corner of Camden Street and Harcourt Road, from which the name 'Kelly's Corner' derives. Mistaking the Alderman for a rebel, the soldiers destroyed the shop with hand grenades. On the way back to the barracks through Portobello, Sheehy-Skeffington was the witness to two murders committed by Bowen-Colthurst and his party on two unarmed civilians, one of them a seventeen-year-old boy from Mountpleasant Avenue returning from the nearby church.

The following morning Bowen-Colthurst ordered his sergeant to organise a firing squad to shoot Sheehy-Skeffington and two journalists – Thomas Dixon (a disabled Scotsman) and Patrick McIntyre – who were unlucky enough to have been in Kelly's shop when it was raided. The three were shot in the back as they walked towards a wall in the barracks

yard. The authorities tried to hush up the murders, and in fact even offered Bowen-Colthurst command of a regiment in Newry. But as soon as Bowen-Colthurst's commanding officer, Sir Francis Fletcher Vane, found out what had happened he tried to have Bowen-Colthurst arrested for murder, and was sacked from the army for his pains. As the Public Records Office put it, 'this officer was relegated to unemployment owing to his action in the Skeffington murder case in the Sinn Féin rebellion'. Bowen-Colthurst pleaded insanity at a later investigation and was jailed for eighteen months.

Arthur Griffith and the Barracks

Meanwhile, Wellington Barracks was also seeing a lot of action. Insurgents attacked it during the 1916 Rising. After the surrender, Éamon de Valera was held prisoner in the detention cell of the barracks from 3 May to 5 May, along with Count Plunkett (father of Joseph Mary Plunkett), Larry O'Neill (future Lord Mayor of Dublin), and others. On the afternoon of Monday 8 May, de Valera was tried for his part in the Rising. After the trial he was transferred to Kilmainham Jail.

The change from Wellington Barracks to Griffith Barracks occurred on 15 April 1922 when it became one of the first to be handed over to the Irish Free State and was garrisoned by the new Irish Army. It was later renamed by the Army Council in honour of Arthur Griffith, following his death in August 1922.

During the subsequent Irish Civil War (1922-1923), the barracks was attacked by the Anti-Treaty IRA, from Clanbrassil Street Bridge and areas along the Grand Canal. In one such attack, five people were killed. On 8 November 1922, Anti-Treaty fighters again fired on troops drilling in the main square at the barracks from positions across the Grand Canal, using Lewis and Thompson machine guns and rifles. One soldier was killed and fourteen injured (seven seriously), two civilians were also killed and many injured. Free State reinforcements were rushed to the scene, and two of the IRA attackers were killed and six captured, along with a machine gun.

In reprisal for the attack, a Republican, James Spain, was killed. He may have taken part in the attack on the barracks and was wounded in the leg. Two hours after the action, he was pursued by Free State troops, taken out of a nearby house on nearby Donore Avenue and summarily executed.

In 1939, part of the barracks was leased to the Irish Amateur Boxing Association as the site for the National Boxing Stadium that was opened by Irish Government Minister, Frank Aiken.

In 1991, the last soldiers left the barracks and the site was handed over to the Office of Public Works as part of a government programme of closing a number of military installations around the country.

In 1992, the Office of Public Works sold the barracks and it became the site of Griffith College Dublin. The college has developed the site with a number of buildings being refurbished as well as new structures being built. In 1998, Griffith Barracks National School was opened in the Guardhouse building and parade ground site at Griffith Barracks, South Circular Road. President Mary McAleese officially opened it in April 1998.

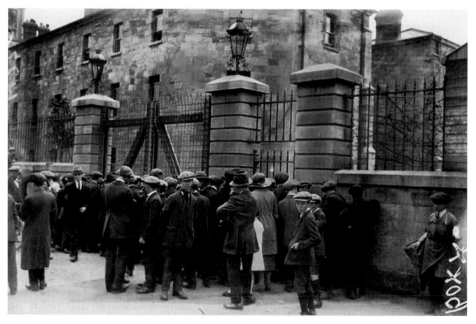

The attack on Wellington Barracks, 8 November 1922, during the Civil War. Crowds surround the Barracks after the attack. (Courtesy of John Dorney/The Irish Story)

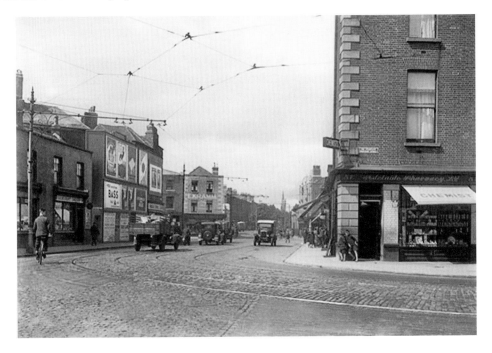

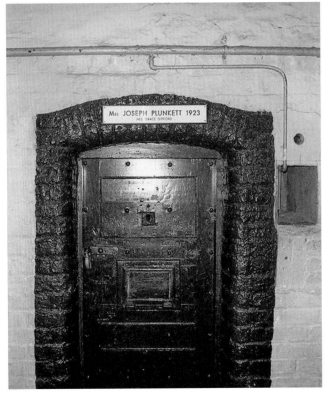

Above: *A view from Harcourt Road at the top of Harcout Street. First left is Charlemont Street, straight ahead, Harrington Street and in the distance St Kevin's church, early 1900s. (Courtesy of Bang Bang/Dublin.ie Forums)*

Left: *The Kilmainham Jail cell of 1916 Rising leader Joseph Mary Plunkett where he married Grace Gifford on the eve of his execution. Grace Plunkett (née Gifford) (1888-1955), died in her apartment in South Richmond Street and her funeral was held in nearby St Kevin's church Harrington Street. (Courtesy of Portobello Heritage Society)*

Riot in Richmond Street

On 22 March 1920, an incident, typical of the time, occurred in the area. A large group of British soldiers of the Royal Berkshire Regiment, were returning, singing, to their nearby barracks after a night out on the town. They started jostling pedestrians in Grafton Street and Harcourt Street. At Kelly's Corner a crowd gathered who attacked them with stones. By the time they reached Lennox Street in Portobello, gunfire had broken out and one soldier was shot in the chest. A running fight along the street developed until armed reinforcements arrived from the barracks. Gunfire broke out between the two sides, and the soldiers forced the crowd back towards Camden Street, firing at them when they did not obey the command to disperse. A van driver and a female domestic were killed, and many injured.

1923 Stamer Street Shooting

In the Jewish Museum on Walworth Road, a photograph hangs of Emmanuel 'Ernest' Kahn, of Lennox Street. On the evening of 14 November 1923, Kahn, together with David Millar, had been playing cards in the Jewish Club on Harrington Street, but while walking home they were confronted by a number of men who demanded their names and religion. Following a brief altercation the two men turned to leave, were then shot, and Kahn was killed. What followed was only made fully apparent after the release of documents from the National Archive, which show that two men, Ralph Laffan and his brother Fred, were falsely accused of the murder, and absconded to Mexico. The person behind the murder was actually Commandant James Patrick Conroy, who shortly after resigned from the army and left the country.

Up in Smoke!

On 1 July 1943, the South Circular Road was the scene of a robbery by the IRA, then hard-pressed by the Irish Government of Éamon de Valera due to the on-going war. Charlie Kerins, IRA Chief of Staff at the time, and his fellow militants Archie Doyle and Jackie Griffith, arrived on bikes at the gates of the Player Wills cigarette factory on the South Circular Road. With scarves around their faces, they stopped at gunpoint the van with some £5,000 for wages, and drove away with the van and the money, which was used to finance the organization's operations.

A final note: Grace Plunkett (*née* Gifford) (1888-1955), widow of 1916 Rising leader Joseph Mary Plunkett, died in her apartment in South Richmond Street in 1955 and was taken to nearly St Kevin's church in Harrington Street for her funeral Mass.

2

STREETS BROAD AND NARROW

The Harbour

Portobello Harbour commenced business in 1801, just five years after the opening of the Grand Canal in April, 1796. The City Basin, between Lennox Street and the canal, was used as a reservoir for parts of south Dublin for many years. However, because of questions over the water quality, it ceased production in 1863 with the opening of the Vartry reservoir.

Development

Most of the area was developed in the latter half of the nineteenth century, the houses along the South Circular Road being built between 1850 and 1870, although the smaller houses off Lennox Street were built by the Dublin Artisans' Dwellings Company some time later, from 1885, just in time for the increasing number of Jewish people looking for houses in the area. This company also built houses on that part of Portobello Basin that was filled in 1883.

In 1868, a new street was opened to connect Harold's Cross with Lower Clanbrassil Street. The Lord Mayor, the aldermen and Frederick Stokes, who had purchased the land and led the project, attended the opening. The

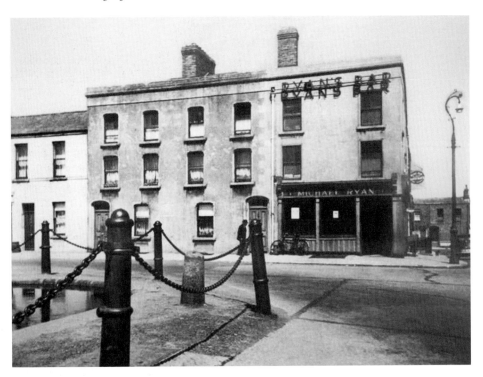

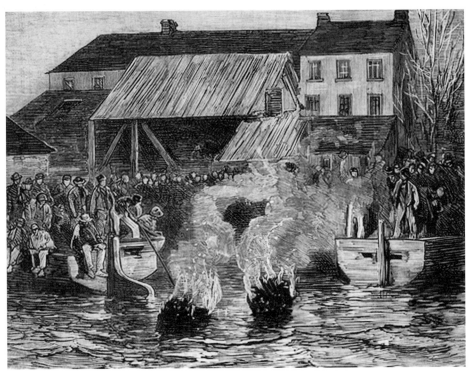

Opposite, from top:

Portobello harbour in the 1930s. Subsequently the water was filled in, saying goodbye to the old harbour. Ryan's Bar, established in 1867, is now The Lower Deck. (Courtesy of Damntheweather/ Dublin.ie Forums)

Portobello harbour in 1882. This is from The Graphic *of 13 May 1882, and shows the lighting of tar-barrels in Portobello harbour, on the Grand Canal at Portobello bridge, to celebrate the release from prison of Charles Stewart Parnell and two colleagues from prison. Parnell the 'uncrowned king of Ireland' had been imprisoned for his support for boycotting and of the successful Plan of Campaign which sought Fair Rent, Free Sale and Fixity of Tenure for the tenants of Ireland. (Courtesy of Irish Waterways/OPW/ Portobello Heritage Society)*

Right: *Crowley's shoe repairs shop of 44 New Street, in 1961. (Courtesy of 'Clanbrassil Street 1' by Sean Lynch and Holly O'Brien)*

street was to be called Kingsland Street, but in fact, that name was never used, and it became Upper Clanbrassil Street.

The two St Kevin's churches were built in the last quarter of the nineteenth century along Harrington Street and the South Circular Road. St Kevin's Catholic church in Harrington Street was completed in 1871, and the Church of Ireland St Kevin's in 1883. The Donore Presbyterian church, now the Dublin Mosque, was built in 1884.

In the 1960s, the Garda Club opened in Harrington Street and Synge Street School obtained a new building fronting onto Heytesbury Street. The Bleeding Horse came under new management, introduced plastic fittings and changed its name to the Falcon Inn.

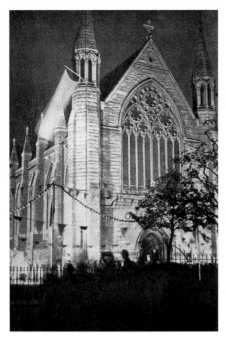

St Kevin's church, Harrington Street is illuminated and passers-by admire the decorations at the Bank of Ireland building in College Green. (Courtesy of the Central Catholic Library)

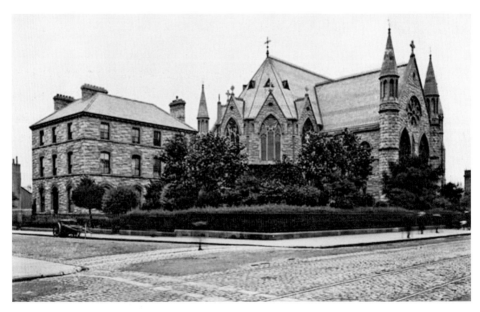

Early photograph of St Kevin's church, Harrington Street, c. 1910. (Courtesy of the National Library of Ireland)

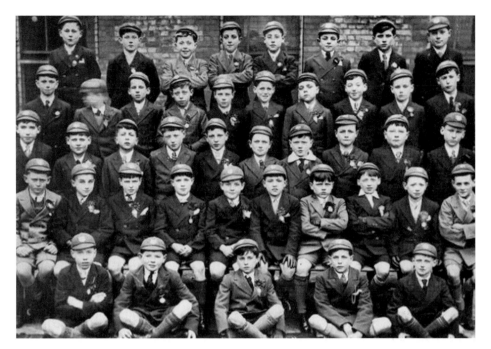

A Synge Street school confirmation class photo from the 1930s. A boy has turned suddenly just as the photo was taken. Can you spot him? (Courtesy of Synge Street CBS Schools)

The South Circular Road

Starting in the 1980s, Kelly's Corner was re-developed. Old Camden Street and Charlotte Street disappeared and the ruined buildings there made way for the Camden Court Hotel. The north side of Harcourt Road was developed, Stein's the opticians being the last to go in the first phase, and Gleeson's Pub in the second.

The South Circular Road (SCR) is a road that passes through Portobello and is one of the longest in the city. It runs from Kilmainham in the west of the city, through Rialto and Dolphin's Barn to Portobello. As it runs mainly through residential areas, it is used by numerous bus routes and was formerly an important tram route.

Until the early eighteenth century most of the area covered by the road was countryside. Residential development of the South Circular Road began in earnest at Portobello around 1860 when estates such as

Emorville and Portobello Gardens were put up for sale as development land. Speculative developers are not a recent invention of the Celtic Tiger era. It quickly continued along the length of the road into the 1890s.

The first Jewish people, fleeing conditions in Lithuania, arrived in Dublin in the early 1870s and eventually settled off Lower Clanbrassil Street. In the decades that followed many of them settled along the South Circular Road, both sides of Leonard's Corner, and in the side streets off it. There was a Jewish dairy opposite what was then Wellington Barracks.

James Joyce Ambles Along the SCR

In the 'Ithaca' chapter of Joyce's *Ulysses*, the question is posed, 'Had Bloom discussed similar subjects during nocturnal perambulations in the past? In 1884 with Owen Goldberg and Cecil Turnbull at night on public thoroughfares between Longwood avenue and Leonard's corner and Leonard's Corner and Synge Street and Synge Street and Bloomfield Avenue.'

Fireworks in the Portobello Gardens

Part of Lennox Street, Victoria Street and Florence Street stretching from the canal to the South Circular Road were part of the Kingsland estate, which contained a park with a large pond and fountains, and which opened as the Royal Portobello Gardens in 1839. The name survives in Kingsland Park Avenue.

From 1858, Messrs Kirby and Webb leased the Portobello Gardens. Kirby was a pyrotechnician who lived in Sackville Street. During the summer months, gas and Chinese lamps illuminated acrobats, dancers a band and 'a highly trained troupe of performing dogs' entertained the public.

A huge attraction at the gardens was the well-known tightrope walker Charles Blondin, who first performed at the gardens in August 1860. The previous year he had caused a sensation by crossing the Niagara Falls on a tightrope. In May, at the Crystal Palace, he had carried across a stove on the

Clockwise from right

The Provincial Bank constructed in a restrained classical style in 1923. (Courtesy of Portobello Heritage Society)

Map of Portobello's and Dublin's 'Little Jerusalem' (adapted from educational Jewish aspects of James Joyce's Ulysses). (Courtesy of Wordpress)

A cartoon of Leopold Bloom (of 52 Clanbrassil Street) by James Joyce, author of Ulysses.

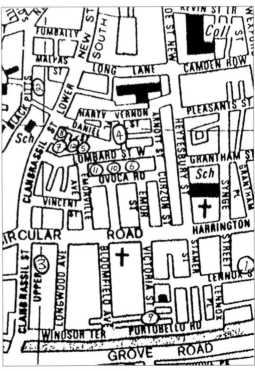

rope, then, still suspended on the wire, proceeded to cook omelettes, which he distributed to the audience below. On the evening of 23 August 1860, however, as the crowd packed the gardens, the tightrope broke, which led to the supporting scaffolding collapsing. Blondin was not injured, but two workers who were on the scaffolding fell to their deaths. Although they appeared as witnesses at an initial investigation, Blondin and his manager failed to appear at a further one, as they were in the USA, and a warrant was issued for their arrest. However, things must have been worked out in the end, because in August of the following year found the, 'far-famed funambulist' performed his 'arduous and daring exploits' at the gardens followed by 'Madame Veroni's magic exploits'.

Meanwhile the proprietor of the gardens, Kirby, the pyrotechnician, was having problems with a pyromaniac, several attempts having been made on his property. In 1862, Kirby was the victim of arson, both the music hall in the gardens and his house in Sackville Street were burned down, resulting in high claims for compensation. Plans for developing the land at the gardens for housing started around this time. Frederick Stokes, JP, an Englishman, the main developer of Rathmines and Portobello at the time, and chairman of the Rathmines Township Commissioners, who drained it and let it out in building lots, purchased the land.

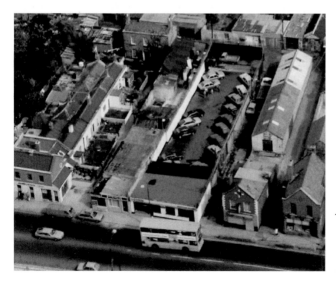

An aerial view from the Ken Finlay collection shows how far building plots stretched back from the street. (Courtesy of 'Clanbrassil Street 1' by Sean Lynch and Holly O'Brien)

Queen Victoria and the Ladies of the Night

Victoria Street was originally called Kingsland Park and was developed from 1865 by property developer Frederick Stokes. For many years it was a renowned 'red-light district' facilitating the soldiers in the two adjacent soldiers' barracks. In an attempt to upgrade the area the name and a few other road names (e.g. Windsor Terrace) in the area were changed around the time of Queen Victoria's visit to Dublin at the turn of the twentieth century. Carved images of Queen Victoria's head may still be seen on a number of doorways along Victoria Street and illustrate the welcome she received when she came to visit Dublin in 1900.

Emorville and *Ulysses*

Across from the Portobello Gardens was Emorville Estate, which was owned by Joseph Kelly, proprietor of the City Saw Mills in Thomas Street. In the 1860s he decided to develop the estate. Today Emorville Avenue marks the spot. The estate was originally the site of the Leinster Cricket Club (founded in 1852) until they moved to their present site in Observatory Lane, Rathmines, in 1865.

Several streets in the area, e.g., Richmond, Harrington, Curzon, Lennox, Heytesbury and Camden were named after British Viceroys. Newer streets were often named after the estates they were built on. Stamer Street, developed around 1880, was named after Sir William Stamer, Lord Mayor in 1809 and 1819. Abandoned babies left at St Kevin's church were often named after one of the nearby streets. Emorville Avenue has links with the writer of *Ulysses*, James Joyce as it was his parents' first home (No. 30) after they got married in 1881, before moving to Rathgar where James was born the following year.

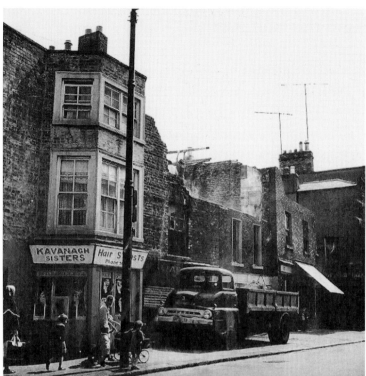

Masterson's Lane, off Charlemont Street, 1964. (Courtesy of Polito45/Dublin.ie Forums)

A furniture shop on Lower Clanbrassil Street. (Courtesy of 'Clanbrassil Street 1' by Sean Lynch and Holly O'Brien)

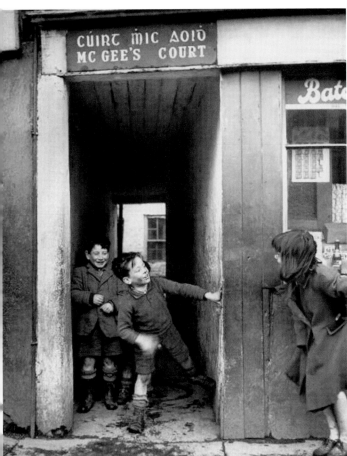

Left: *Children up to mischief at McGees Court off Camden Street in the 1940s. (Courtesy of Dublin.ie Forums/ Damntheweather)*

Below: *A shopkeeper reading in her grocery shop off Camden Street in the early 1940s. (Courtesy of Dublin.ie Forums)*

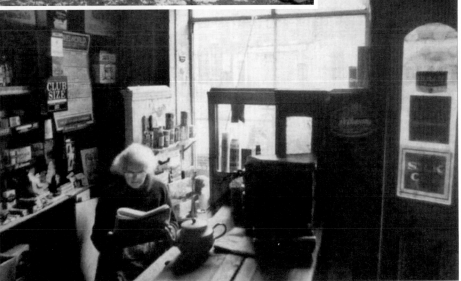

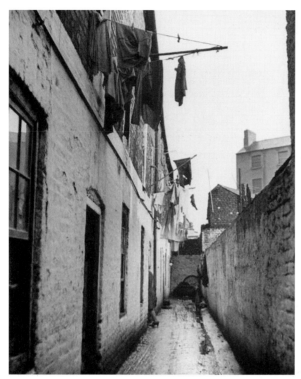

Left: *A grim tenement scene with washing hanging at McGees Court off Camden Street, 1940s. This would have been a typical scene in many of the back alley's and side streets off the finer roads of Portobello. (Courtesy of Dublin.ie Forums/ Damntheweather)*

Below: *Regency building at Harcourt Terrace, along the Grand Canal. 6-7 Harcourt Terrace is an exceptionally elegant and unique Palladian-style Regency property built in early 1840s. This fine building is a listed building on a virtually intact regency street. It is Dublin's only formally planned block of houses from the Regency period. The ten houses in the terrace were built in the 1840s by John Jasper Joly and laid out in pairs. (Courtesy of Portobello Heritage Society)*

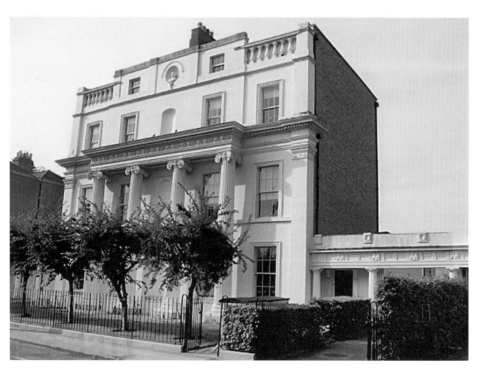

Camden and Wexford Streets

Camden Street and Wexford Street are vibrant market streets comprising part of a medieval route from the southern suburb of Rathmines into Dublin city, via Portobello Bridge. The road developed over the course of the eighteenth century and became lined with brick houses occupied by professionals and aristocracy often associated with nearby Dublin Castle. Today the streets exhibit a strong, nineteenth-century mercantile tradition, with their bustling mixture of shops, service providers and market traders.

Harcourt Terrace

Harcourt Terrace is an elegant, largely residential area and the street has become a quiet backwater since being closed to through traffic. John Jasper Joly erected the houses some time after 1824, and ten houses were laid out in pairs with single-storey partitions in between. Four pairs of stuccoed semi-detached three-storey houses flank a grandiose four-storey central pair. Each of the former has a five-bay front and a massive brick chimneystack and shallow parapet gable to the central bay.

Originally built at right angles to the Grand Canal, and adjoining the now vanished terrace of Charlemont Place, it is located in a quiet part of the city centre only a few minutes' walk from St Stephen's Green. This elegant residential enclave along the Grand Canal has attracted a variety of artists: Sarah Purser rented No. 11 for a time, Micheál Mac Liammóir and Hilton Edwards lived at No. 4, and the first performance of George Russell's (Æ) *Deirdre* was staged in the back garden of No. 5 in January 1902.

Clanbrassil Street

Clanbrassil Street is a street at the other extremity of Portobello. It runs from Robert Emmet Bridge on the Grand Canal to New Street. It is named after James Hamilton, 2nd Earl of Clanbrassil.

Left: *1980s cartoon showing the link between the early Vikings in Dublin, when Clanbrassil Street formed part of the ancient Slighe Chualann route from the city to Wicklow and beyond, and the modern-day 'Vikings' who turned the route into a dual carriageway. (Courtesy of Sean Lynch and Holly O'Brien)*

Below: *The General Sales Shop on Clanbrassil Street, Portobello, 1965. (Courtesy of Matt Hackett/Sean Lynch and Holly O'Brien, 'Clanbrassil Street 1')*

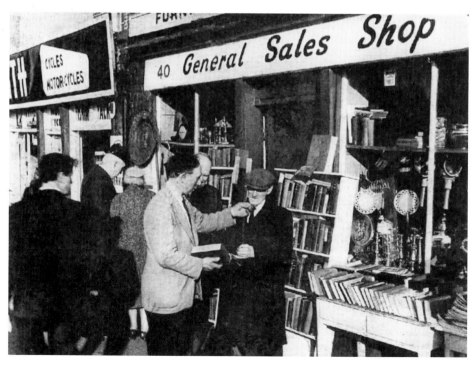

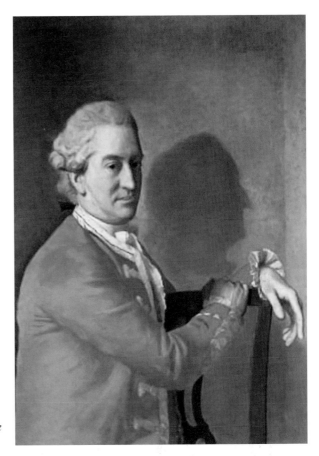

James Hamilton (1730-1709), 2nd Earl of Clanbrassil. He became Earl of Clanbrassil in 1758 on the death of James Hamilton, 1st Earl of Clanbrassil. (Courtesy of Jean-Étienne Liotard/Portobello Heritage Society)

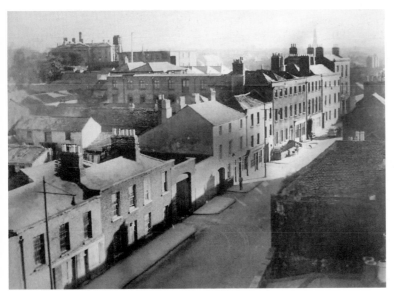

A view of New Street from Clanbrassil Street in 1962. (Courtesy of 'Clanbrassil Street 1' by Sean Lynch and Holly O'Brien)

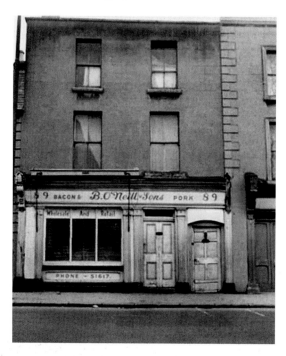

The old butcher's shop, Clanbrassil Street, 1963, just before you get to Larkin's Pub (The Bunch of Grapes) on the corner of Donovan's (Ducker's/ Dowker's Lane). (Courtesy of Damntheweather/Dublin.ie Forums)

The rear of some of the tenements on Charlemont Street c. 1950s and prior to their demolition. Notice washing hanging out upstairs window. Each house would have contained at least a half a dozen families. (Courtesy of Polito45/Dublin.ie Forums)

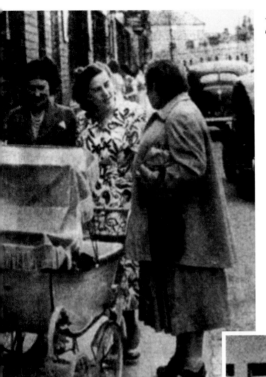

Admiring the baby in the pram and having a chat on Clanbrassil Street in the 1940s. (Courtesy of Auld Decency/Dublin.ie Forums)

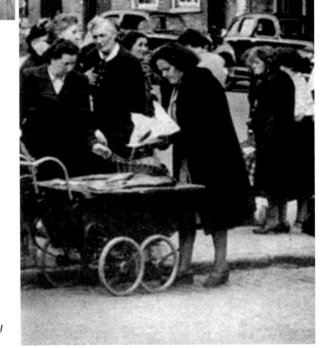

Selling fish from a baby's pram on Clanbrassil Street, 1940s. (Courtesy of Auld Decency/Dublin.ie Forums)

From earliest times, the street formed part of the Slige Chualann, which ran south to Wicklow and the rest of Leinster from the settlement at Dublin. In 1868, a new street was opened to improve this route linking Harold's Cross, Terenure, and Kimmage into the city with Lower Clanbrassil Street. The Lord Mayor, the aldermen and Frederick Stokes, who had purchased the land and led the project, attended the opening. Between 1886 and 1892, 128 houses were built off Clanbrassil Street, on Daniel Street and Harty Place, by the Dublin Artisans Dwelling Company for the industrial and working classes.

Lower Clanbrassil Street was known as part of Little Jerusalem because in the first half of the twentieth century it was at the heart of the Jewish community in Ireland. The first Jewish people, fleeing conditions in Lithuania, arrived in the early 1870s and eventually settled off Lower Clanbrassil Street. In its heyday Clanbrassil Street was a thriving Jewish enclave of kosher butchers, fishmongers, grocers, synagogues, and shops.

The Four Corners of Hell

In 1953 plans were announced for compulsory purchase orders on many of the dwellings along Lower Clanbrassil Street for the purposes of road-widening. This was much uproar and as a consequence the plans were amended and put on hold until the 1980s. Unfortunately one of the consequences of the delay was that over the years the street and many of the houses fell into disrepair. Eventually work on a four-lane road began in 1989 and many of old houses, shops and pubs in the area were demolished.

At the junction of Patrick Street and New Street, four pubs (one of each corner) known as the 'Four Corners of Hell' (called this by some visiting Mission priests because of the amount of alcohol consumed in the area), were demolished, as was another well-known pub, the Bunch of Grapes, formerly Fitzpatrick's, which was built in 1739.

Right: *Clanbrassil Street before demolition and widening, 1987. (Courtesy of 'Clanbrassil Street 1' Sean Lynch and Holly O'Brien. Ken Lawford/ Paul Harris)*

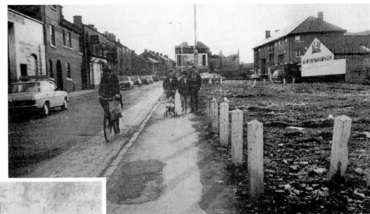

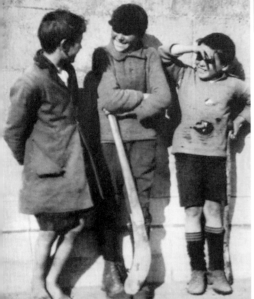

Left: *Tenement children from the Tenters, off Clanbrassil Street, having a break from a game of hurling in the 1930s. Notice the bare feet of one of the boys – this would have been typical for many children and eventually led to the Herald Boot Fund of the 1940s to put shoes on many of Dublin's children. (Courtesy of Dublin. ie Forums/Jimmymac)*

Right: *Nineteenth-century houses on the east side of Lower Clanbrassil Street. (Courtesy of Portobello Heritage Society)*

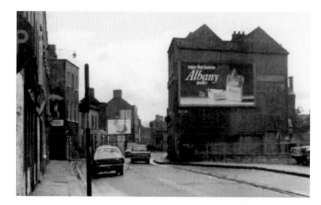

A view looking south on Clanbrassil Street gives an idea of the width of the street before widening began. (Courtesy of 'Clanbrassil Street 1' by Sean Lynch and Holly O'Brien)

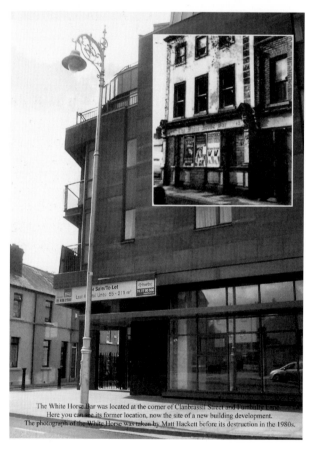

Changing times: the corner of Clanbrassil Street then (insert) and now. (Courtesy of 'Clanbrassil Street 1' by Sean Lynch and Holly O'Brien)

The White Horse Bar was located at the corner of Clanbrassil Street and Fumbally Lane. Here you can see its former location, now the site of a new building development. The photograph of the White Horse was taken by Matt Hackett before its destruction in the 1980s.

3

TRAINS, TRAMS, BARGES AND BIKES

From the 1850s, horse-drawn omnibuses provided transport along South Richmond Street from Rathmines to the city centre. On 6 October 1871, work began on the Dublin tram system on Rathmines Road, a few yards from Portobello Bridge. They came into operation the following year, linking Rathgar, via Richmond Street, with College Green. There was just one standard fare within the city limits, which was much cheaper than the old horse-drawn omnibuses. That year, also, the long-awaited improvements to Portobello Bridge were carried out, the Tramway Company paying one third of the total cost of £300.

At the time the trams were introduced, the curve in the street at Moyer's building works, west corner of Lennox Street, now part of the Portobello College complex, was an impediment to efficient transport along Richmond Street. The constant traffic in and out of Moyer's blocked the traffic at this narrow spot. Despite complaints, the curve was never removed, and is there to this day.

Charlemont Bridge was called after Charlemont Street which in turn was named after the Earl of Charlemont. The earl was the general of the Irish Volunteers and a friend of Henry Grattan of Grattan's Parliament fame. Portobello Bridge is also known as La Touch Bridge. It crosses the canal by the Portobello Hotel that used to be a major staging post in the city where travellers boarded for the trip west.

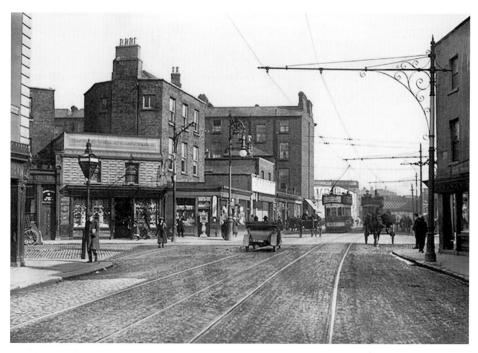

New forms of transport meet the old at Harcourt Street/Charlemont Street Junction, c. 1910. (Courtesy of the National Library of Ireland)

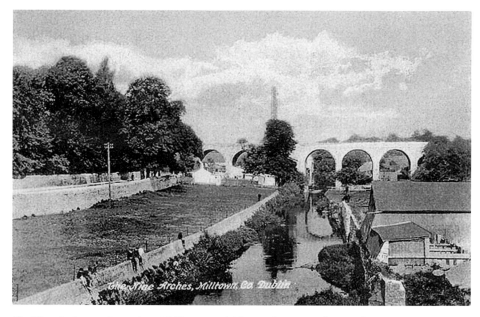

The Nine Arches as shown in a 1909 postcard. This viaduct carried trains from Harcourt Street to Dundrum and it now carries the Luas tram. (Courtesy of Portobello Heritage Society)

A Terrible Tragedy at Portobello Bridge

At 9 p.m., Saturday, 6 April 1861 near Portobello Bridge, a horse-drawn bus, driven by Patrick Hardy, had just dropped off a passenger and started up the steep incline of the bridge when one of the horses started to rear. The driver tried to turn the horses but both horses became uncontrollable with fear and backed the bus through the wooden rails of the bridge. The bus, horses and six passengers inside the bus, plunged into the dark cold waters of the canal lock, which was about twenty feet deep, with ten feet of water at the bottom. The conductor was able to jump clear and a passing policeman pulled the driver from the water. Despite the frantic efforts of passers-by, in particular a constable and a soldier from Portobello Barracks who broke their way into the submerged bus, all inside were drowned. One of those killed was the father of the Gunne brothers, who opened the Gaiety Theatre. Two were mothers, each with a little girl, one of them a niece of Daniel O'Connell.

The repercussions of this tragedy were felt for a long time in the area. Passengers on horse-drawn vehicles had to alight at Portobello Bridge and walk across the bridge before continuing their journey. According to some accounts, on the night of the accident a brilliant light was seen to rise from the canal water and turn into a human shape. They say the ghost of a lock-keeper, who drowned himself after being sacked for drunkenness, was to blame for the tragedy.

Harcourt Street and the Train Crash of 1900

Harcourt Street railway station, opened in the late 1850s, was the terminus of the line from Dublin to Bray. The front was designed by George Wilkinson, and contained a central arch and a colonnade of Doric columns. The station itself was built on a raised level, which led to the platforms also being raised. There was a storage area in the basement used by Gilbeys the wine and spirit distributors.

The station is often remembered (and strangely celebrated in posters and pictures) for the train crash in 1900. A train from Enniscorthy failed to stop

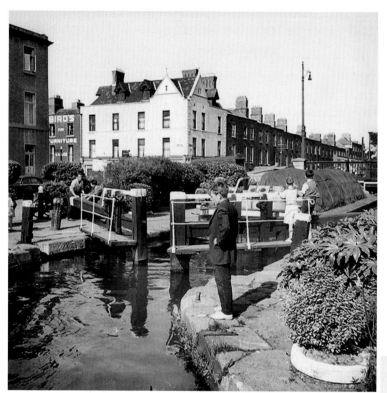

A barge going through lock gate at Portobello Bridge, c. 1959. (Courtesy of the National Library of Ireland)

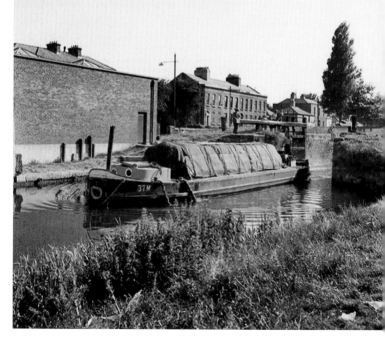

A barge travelling along the Grand Canal away from Portobello towards Mount Street, 1959. 9Courtesy of the National Library of Ireland. Dublin.ie Forums/Steevo)

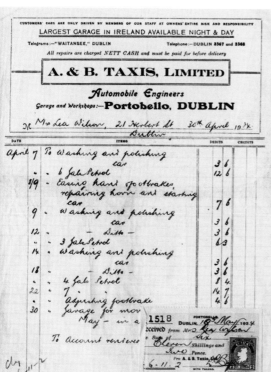

A & B Taxis Portobello receipt. This receipt is made out to Mrs Lea Wilson for the servicing of her car. (Courtesy of Dublin City Libraries/Dublin.ie Forums)

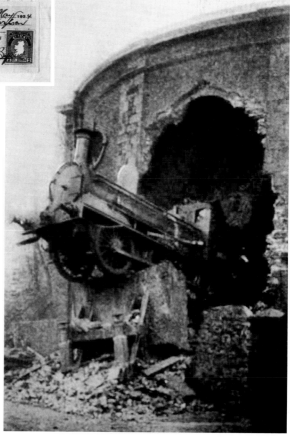

Harcourt Street train crash, 1900. Despite extensive rail traffic, there were no major mishaps at any of the Dublin termini until the evening of 14 February 1900 when a steam locomotive went out of control and broke through the end wall of Harcourt Street station, finishing up hanging up over Hatch Street where it remained in this precarious position until it was taken down. It is one, if not the main, event associated with the station. Uniquely, Harcourt Street station, which was opened in 1859, was at the foot of a gradient that sloped downwards from Ranelagh and this meant that locomotive drivers had to exercise extreme care when approaching the station. (Courtesy of Dublintraincrash.net)

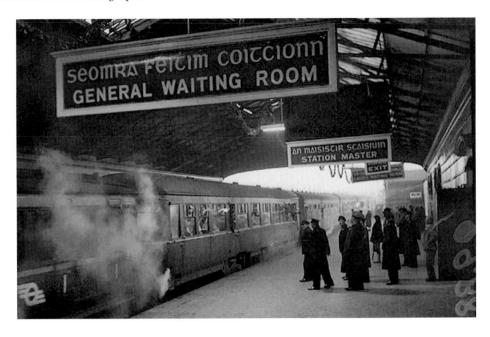

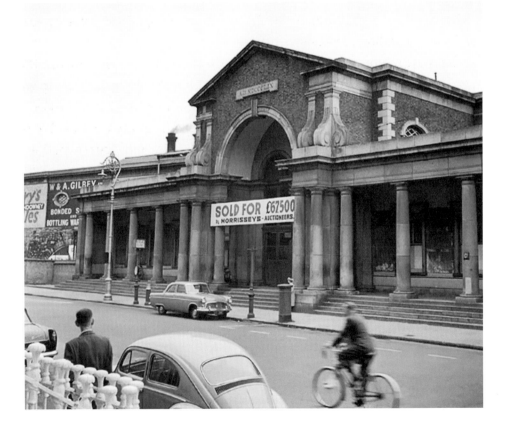

Frank Carvey & Sons in Camden Street were Irish agents for Jaguar, assembling SS saloons since 1937 and MkV ad MkVIIs immediately after the war. Six CKD 120 roadsters were received by Carvey's in early 1951 and the first car was assembled in Dublin that summer. Another six roadsters were assembled and sold in 1952 along with another twenty or so XKs directly imported fully assembled.

Opposite, from top:

The last train from Harcourt Street station, December 1958. (Courtesy of the National Library of Ireland)

Harcourt Street railway station in 1959, displaying a big 'Sold' sign. (Courtesy of National Library of Ireland)

and crashed through the end wall of the station onto Hatch Street, with the engine left dangling in mid-air.

The station continued operating until 1958, when CIE, during its rationalisation programme of the railway network, closed the line from Harcourt Street. Luckily, most of the track and bridges were retained and the Luas tram system, which opened in 2004, utilises the upgraded and much-improved route, with a new stop opened in front of the old station. The railway station has other uses now and is a listed building.

4

TWIN PEALS: THE TWO ST KEVINS

The ruins of the original St Kevin's church are just off Heytesbury Street and are well worth a visit. The church dates back at least as far as the thirteenth century, and was dedicated to Kevin of Glendalough. Many famous people in Irish history are buried there, including the executed Archbishop Dermot O'Hurley, the family of Thomas Moore and John Keogh (1740-1817), intimate friend of Theobald Wolfe Tone, who once owned the land where Mount Jerome Cemetery now stands.

This part of Dublin has long been associated with St Kevin, the hermit and founder abbot of the world famous Glendalough in County Wicklow, who died in 618. The name St Kevin features strongly in the Portobello area with churches and roads named after the saint. In the twelfth century, when the parochial system was first introduced, a parish of St Kevin was established south of the city walls. The modern St Kevin's church opened in Harrington Street in 1872 to serve the Catholic parish of St Kevin, which had been split from St Catherine's in 1855.

A large field adjacent to the newly laid out South Circular Road was purchased by the parish priest of St Nicholas of Myra, Francis Street, in 1861. The following year a temporary wooden chapel of ease, dedicated to St Kevin, was opened. In 1865, a new parish of St Kevin's was constituted with the intention of building a permanent church. Pugin and Ashlin,

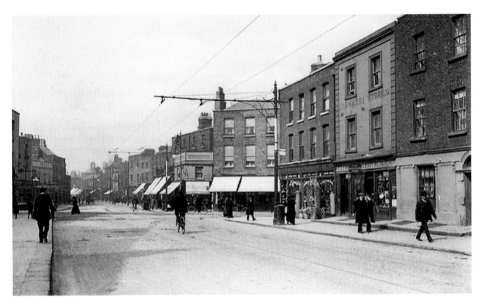

View looking from the end of Charlemont Street, 1910. Charlotte Street straight ahead. Right is Harcout Road; left is Harrington Street and St Kevin's church. (Courtesy of Bang Bang/Dublin. ie Forums)

The Farrell family lived a few doors up from Keogh's near Leonard's Corner. (Courtesy of Auld Decency/Dublin.ie Forums)

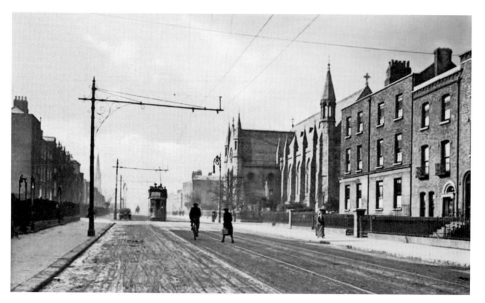

Harrington Street and South Circular Road, c. 1900. St Kevin's church is on the right. (Courtesy of the National Library of Ireland)

Carol Singers from Donore Parish, adjacent to Portobello, 1953. (Courtesy of Dublin.ie Forums/ tonybrun1952)

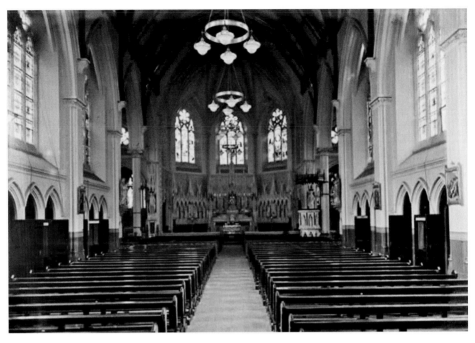

The interior of St Kevin's church, Harrington Street.

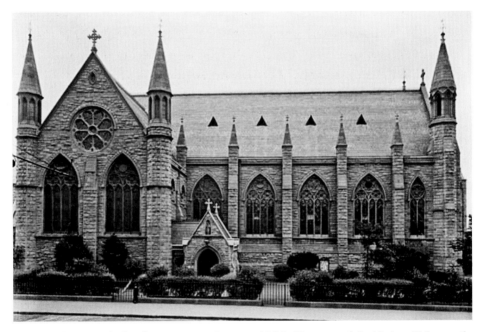

Exterior of St Kevin's church, Harrington Street, c. 1930. (Courtesy of the National Library of Ireland)

the leading Dublin firm of church architects established by Edward Welby Pugin (1834-1875), the elder son of the great Gothic revival architect A.W.N. Pugin, was commissioned to provide the designs for the new church. E.W.N. Pugin had invited his Irish pupil George Coppinger Ashlin into a partnership to establish and run an office in Dublin and to take charge of their Irish commissions. The partnership lasted from 1860 to 1868 and coincided with a period of great expansion in church building. The firm's other great commissions of the 1860s were the churches of SS Peter and Paul, Cork, SS Augustine and John, John's Lane, Dublin and Cobh Cathedral. In January 1869, the builders Michael Meade & Sons of Great Brunswick (later Pearse) Street were contracted to build the church which cost about £20,000. Cardinal Cullen laid the foundation stone for the new church on the feast of St Kevin, 3 June 1869 and the church was dedicated by the Cardinal on 3 June 1872.

St Kevin's is cruciform in plan. The exterior is textured Irish granite with contrasting Portland stone string-courses and dressings. The facades are decorated with large three- and four-light windows and an enormous eight-light window on the entrance front. Turrets flank the nave and transepts which add to the vertical emphasis of the pinnacled buttresses.

The interior comprises a broad aisle-less nave and five-sided apse in the sanctuary. On either side are expansive transepts. The side walls of the nave are punctuated by confessionals, baptistery and a Calvary. The sanctuary is dominated by an elaborate pinnacled reredos of angels, saints and Old Testament scenes that form a backdrop to the high altar. Thomas Earley executed the high altar, designed by Ashlin and erected in 1888. There are four side altars dedicated to St Anne and Our Lady of Good Counsel, The Blessed Virgin Mary, St Joseph and the Sacred Heart.

The church is flanked by its presbytery in Heytesbury Street and Synge Street CBS School in Synge Street.

The School Around the Corner

The main school in the area is Synge Street CBS. Established in 1864, Synge Street School was originally housed in a group of Georgian Houses fronting onto Synge Street. The monastery next to St Kevin's church was home for the brothers and later, many school classes. In 1954, a new primary school was opened on Synge Street leaving the secondary school utilizing several rooms in the monastery building as well as houses in Grantham Street and in Heytesbury Street. During the 1960s, the houses fronting Heytesbury Street were knocked down to make way for the present building, which

In the Spirit of Adventure. A picture of girl guide leader dating from 1937. The headquarters of the Catholic Girl Guides of Ireland were for many years on corner of Harrington Street and Synge Street. (Courtesy of Catholic Guides of Ireland)

Catholic Girl Guides from the locality: St Bernadette's Troupe, 1935, at the back of Archbishop Byrne Hall, Synge Street/Harrington Street junction. (Courtesy of Auld Decency/Dublin.ie Forums)

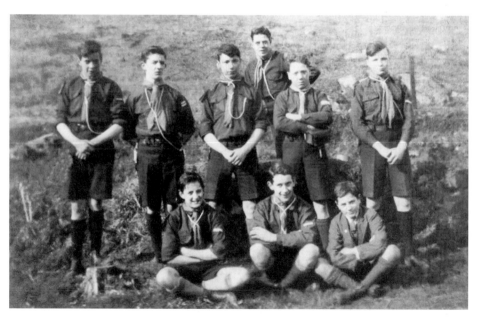

Take a hike: local lads in the Boy Scouts, 1928. Tommy Hickey, from Lower Clanbrassil Street, is the from left, back row. (Courtesy of Auld Decency/Dublin.ie Forums)

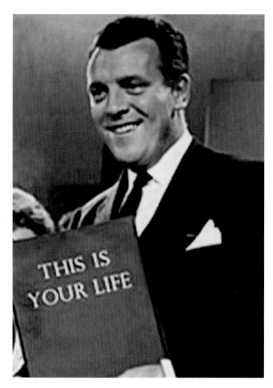

Portobello resident, and Synge Street pupil, Eamon Andrews. Here he is in his early days in the famous UK television programme, This is Your Life. *(Courtesy of Portobello Heritage Society)*

was extended in the early 1980s. The school boasts many famous past pupils including: Eamonn Andrews, television presenter; Niall Andrews, politician; Harry Boland, Irish Volunteer; Gay Byrne, television and radio presenter; Liam Cosgrave, former Taoiseach; Louis Ellimann, former owner of the Gaiety Theatre and the Theatre Royal; Don Givens, footballer; David Kelly, actor; Eamon Morrissey, actor; Cearbhall Ó Dálaigh, former President of Ireland; Brian O'Nolan, who wrote under the pseudonym Flann O'Brien; Milo O'Shea, actor; James Plunkett, writer; Noel Purcell, actor; Cornelius Ryan, writer; Richie Ryan, former Fine Gael Minister for Finance (affectionately known as 'Richie Ruin'); Cecil Sheridan, comedian, and many, many more.

The school has also made history in the area of science as it is the only school in Ireland that has, on three occasions, won the annual Young Scientists Exhibition!

On the other side of Synge Street is St Kevin's Hall (also know as Archbishop Byrne Hall), which is the meeting place for the Catholic Girl

Guides of Ireland. Some readers might recall the huge letters CGGI on the building's wall fronting on to Harrington Street.

There was a Jewish school in Bloomfield Avenue, now Bloomfield House, and synagogues in Walworth Road, now the Jewish Museum, and in Adelaide Road but these are all closed now. On the Adelaide Road a still-functioning Presbyterian church was built in 1841 for a congregation of 800, and in 1863 a smaller chapel for the Irvingites, which later became St Finian's Lutheran church, was built.

The many Muslims now living in the area attend the Dublin Mosque, formerly the Donore Presbyterian church, built in 1884, further along the South Circular Road, and there is also a centre in Harrington Street.

The local Church of Ireland church, St Kevin's, whose construction, in 1883, was financed by a bequest from a Miss Jane Shannon, of Rathgar, was closed in the 1970s and tastefully converted to apartments, while the adjacent church buildings became a community centre.

The little church at the top of Victoria Street formerly belonged to the

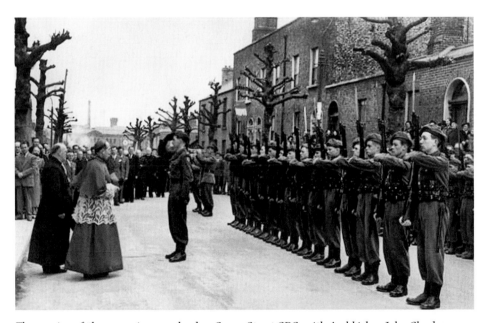

The opening of the new primary school on Synge Street CBS, with Archbishop John Charles MacQuaid receiving a salute from soldiers of the nearby Cathal Brugha Barracks (Portobello), 1954. (Courtesy of Bullfinch1/Dublin Forums.ie)

Above: *Synge Street CBS Schools in 1954. (Courtesy of Synge Street Christian Brothers Schools)*

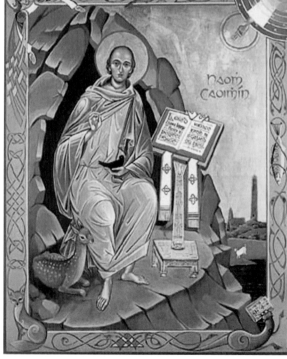

Left: *Icon of St Kevin, taken from the Book of Kells. Two churches and many of the roads in the Portobello area are called after St Kevin. (Courtesy of Portobello Heritage Society)*

Eucharistic Congress celebrations in 1932 in Clanbrassil Street and the nearby Coombe area of the Liberties. (Courtesy of the Central Catholic Library)

Methodist Congregation. It was called Kingsland Methodist Church, and after closing in the 1950s, was used as a women's Employment Exchange. The Methodists also ran the Female Orphanage School in Harrington Street, which was founded in 1804 and closed in the mid-twentieth century.

In 2009, a new national and cultural centre was opened in the Christian Brothers monastery on Synge Street called The Lantern, which is aiming to be a place of hospitality to promote intercultural and interfaith dialogue. The name 'lantern' was chosen to celebrate the life of Nano Nagle who searched the back lanes of Cork each evening with her lantern seeking those who lacked food and shelter. She inspired Edmund Ignatius Rice to found the Congregation of Christian Brothers and the Presentation Brothers with her work for the poor and disadvantaged.

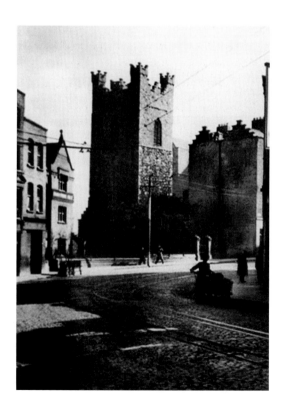

Not too far from Clanbrassil Street: Old Street Audoen's at Cornmarket, 1939. (Courtesy of Auld Decency/Dublin.ie Forums)

5

LITTLE JERUSALEM

In the first half of the twentieth century parts of the area were known as Little Jerusalem, because of the number of Jewish immigrants and refugees, fleeing from persecution in Eastern Europe, who settled there. Most of them came in the 1870s and settled in the Clanbrassil Street area.

The new migrants participated fully in all walks of life, in the professions, trades, and manufacturing. By the 1950s there were nearly 6,000 Jews in Ireland. Over the intervening years, as they became more prosperous many moved to the South Circular Road, Longwood Avenue, Bloomfield Avenue, where a Jewish school was opened, and other parts of Portobello. The shopping area of Little Jerusalem stretched along Lower Clanbrassil Street where there were many Jewish shops and businesses mixed with local Irish businesses.

Founder of the well-known family firm, Myer Wigoder was born in Lithuania but, like so many of the Jewish community, he too had to flee a pogrom. He started a Hebrew class near Kelly's Corner and a synagogue in Camden Street. His son Harry lived at 32 Charlemont Street and was a well-known soccer-player. Another son, a doctor, married into the family of dentist Harry Bradshaw, of 4 Harrington Street. Bradshaw became a leader of the community and founded a synagogue in St Kevin's Parade, just off Clanbrassil Street, and the Jewish cemetery (behind Scoil Íosagáin on Aughavanagh Road) in nearby Dolphin's Barn, where he is buried.

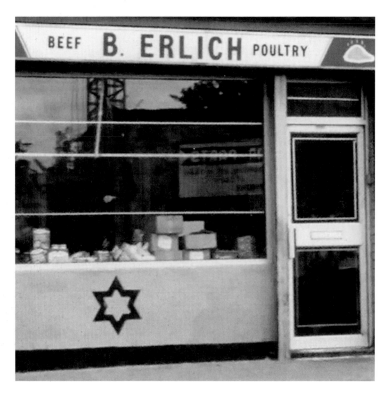

Erlich's butcher's shop on Clanbrassil Street before it closed. (Courtesy of 'Clanbrassil Street 1' by Sean Lynch & Holly O'Brien)

Also from Lithuania, Ada Shillman came to Dublin in 1892 and became a midwife. She started a dispensary for Jewish women in Bloomfield Avenue and helped establish the famous St Ultan's Infant Hospital in Charlemont Street. Her son Bernard became a distinguished Senior Counsel.

In the local elections for Dublin Corporation in 1902, candidate James Connolly (later one of the leaders of the 1916 Rising), standing for Wood Quay Ward, was the only candidate to distribute his election leaflets in the area in Yiddish. Interestingly enough, the name Wood Quay Ward may still be seen high up on the wall over the Leonard's Corner Post Office.

The International Tailors, Machinists and Pressers' Trade Union was established in 1908 by Jewish clothing workers from the area. Its headquarters was at 52 Camden Street (located next to the headquarters for Concern Worldwide). Aaron Klein of 14 Warren Street was its first treasurer. A later secretary was Isaac Baker from Emorville Avenue. A plaque on the wall commemorates the presence of the union in the area.

Shops on Clanbrassil Street in the 1950s. (Courtesy of Portobello Heritage Society)

The Jewish presence in the area declined following the end of the Second World War, with a number of Jews emigrating to Israel, and the majority leaving for New York. Though most of the Jewish population that remained in Dublin have moved out to Terenure, just five kilometres away, a small number still live in the area, but their own shops, schools, and small businesses no longer exist. The long-standing Kosher bakery, the Bretzel, is still in Lennox Street.

Chaim Herzog (1918-1997), sixth President of Israel, grew up in 33 Bloomfield Avenue. His father, Yitzhak HaLevi Herzog, a renowned Talmudic scholar, was the first Chief Rabbi of Ireland, and later of Palestine and Israel. Immanuel Jakobovits (1921-1999), while serving as Chief Rabbi of Ireland lived in Bloomfield Avenue. Leonard Abrahamson, Gaelic scholar, who switched to medicine and became a professor, lodged with the Nurock family near Leonard's Corner while studying at Trinity College, Dublin.

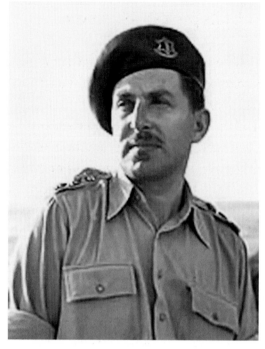

The young Chaim Herzog in Israeli military uniform. He was the son of notable Rabbi Yitzhak HaLevi Herzog, who was Chief Rabbi of Ireland from 1919 to 1937 (and later, of Israel). The family home (from 1919) was at 33 Bloomfield Avenue, Portobello in Dublin. On 22 March 1983, Herzog was elected by the Knesset to serve as the sixth President of Israel. In 1985, during his State visit to Ireland, he opened the Irish Jewish Museum in Walworth Road, Portobello. (Courtesy of Portobello Heritage Society)

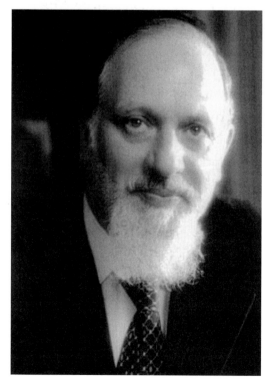

Immanuel Jakobovits (1921-1999), while serving as Chief Rabbi of Ireland (1948-1958), lived at 33 Bloomfield Avenue. (Courtesy of Irish Jewish Museum)

President of Israel Opens the Irish Jewish Museum

The Irish Jewish Museum is located in Portobello. The former Walworth Road Synagogue, which could accommodate about 150 people, consisted of two adjoining terraced houses. Due to the movement of the Jewish people from the area to the suburbs of Dublin and with the overall decline in their numbers, the synagogue fell into disuse and ceased to function in the mid-1970s. The premises remained locked for almost ten years and were brought back to life again with the establishment of the Irish Jewish Museum Committee in late 1984.

The museum was opened by the Irish-born former President of Israel Dr Chaim Herzog on 20 June 1985 during his State visit to Ireland. A committee of dedicated people who voluntarily give of their time, manages it. The museum preserves an important, though small, part of Ireland's cultural and historic heritage. The museum contains a substantial collection of memorabilia relating to the Irish Jewish communities and their various associations and contributions to present-day Ireland. The museum is divided into several distinct areas. In the entrance area and corridors there is a display of photographs, paintings, certificates and testimonials. The ground floor contains a general display relating to the commercial and social life of the Jewish community. A special feature adjoining the area is the kitchen depicting a typical Sabbath or festival meal setting in a Jewish home in the late nineteenth and early twentieth century in the neighbourhood. Upstairs, the original synagogue, with all its ritual fittings, is on view and also the Harold Smerling gallery containing Jewish religious objects.

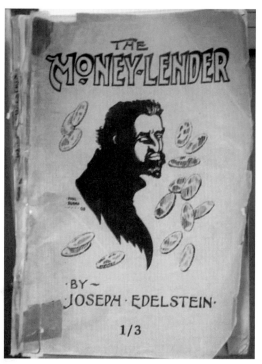

A copy of the book The Money Lender *by Joe Edelstein is held in the Irish Jewish Museum, Walworth Road, Portobello. Joe's name would have been very well-known in the area that became Dublin's 'Little Jerusalem'. He was a businessman and writer of some importance in the Jewish part of the city. The Irish Times of 11 September 1908 noted, for example, that he spoke at a meeting of the Judaeo-Irish Home Rule Association at the Mansion House in Dublin and proposed that '... this great meeting of Jews resolve to support such measures as will tend to secure for the people of Ireland a full grant of self-government.' Edelstein wrote the controversial work,* The Money Lender, *which was not well received in the Jewish community of the capital. It was felt by some that the book reinforced negative stereotypes about the community. It was published in 1908. Despite objections to the work, Joe remained an influential figure in the Jewish community. (Courtesy of Portobello Herit)*

Above *Tommy and Chrissie from 82 Lower Clanbrassil Street, 1942. (Courtesy of Damntheweather/Dublin.ie Forums)*

Right *Buying a hat in Clanbrassil Street in the 1940s. (Courtesy of Auld Decency/Dublin.ie Forums)*

6

A FEAST OF LITERATURE

Conceived in Portobello: James Joyce

James Joyce's parents lived in 30 Emorville Street in 1881, just after they got married. Shortly after they moved to Brighton Square, Rathgar, he was born the following year. Consequently, many pundits say that *Ulysses* was conceived in Portobello! Before their marriage they had both lived in different houses on Clanbrassil Street.

James Joyce certainly did not forget Portobello and in *Ulysses* he mentions the area a few times, 'I saw him a few times in the Bleeding Horse in Camden Street with Boylan, the billsticker' (*Ulysses*, Chapter 16, Eumaeus episode). Not forgetting, of course, that Leopold Bloom, the fictional Jewish character at the heart of the novel lived at '52 Clanbrassil Street'. A plaque commemorating this can be found on the wall of 52 Upper Clanbrassil Street, near Emmet Bridge. Emorville Square, Lombard Street West and St Kevin's Parade, are all mentioned in *Ulysses*.

The Portobello Influence: George Bernard Shaw

Another son of Portobello was the playwright George Bernard Shaw (1856-1950) who was born at 33 Synge Street.

Left: *A gable end at Lombard Street West, with a circular window. (Courtesy of 'Clanbrassil Street 1' by Sean Lynch and Holly O'Brien. Ken Lawford/Paul Harris)*

Right: *The statue of Italo Svevo in Piazza Hortis, in front of the Museum of Natural History of Trieste. Aron Ettore Schmitz (19 December 1861 – 13 September 1928), better known by the pseudonym Italo Svevo, was an Italian businessman and author of novels, plays and short stories. Leopold Bloom is the fictional protagonist and hero of James Joyce's* Ulysses. *His peregrinations and encounters in Dublin on 16 June 1904 mirror, on a more mundane and intimate scale, those of Ulysses/Odysseus in* The Odyssey. *Leopold Bloom's character was inspired by James Joyce's close relationship with Aron Ettore Schmitz, author of Zeno's Conscience. The Bloom family lived in Clanbrassil Street, Portobello.*

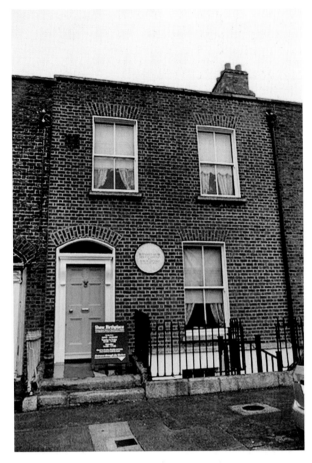

The Shaw birthplace, Synge Street, Portobello. 'Author of Many Plays' is the understated tribute to George Bernard Shaw on the plaque outside his Victorian home. G.B. Shaw was born in Synge Street, Dublin in 1856. The house was opened to the public in 1993. The first home of the renowned playwright has been restored to its Victorian charm and has the appearance that the family have just left for the afternoon. The neat terraced house is as much an exhibition of Victorian Dublin domestic life as of the early years of one of Dublin's Nobel Prize winners for literature. (Courtesy of the Shaw Birthplace Museum/ Portobello Heritage Society)

Nearly all his writings deal with some of the social problems of the day which caught his attention, but they have a vein of comedy to take the bluntness from the seriousness of his themes. He covered many subjects including education, marriage, religion, government, health care and class privilege.

It was in the house on Synge Street, opened to the public in 1993, that Shaw began to gather the store of characters that would later populate his books. From the drawing room where Mrs Shaw held many musical evenings, to the front parlour and children's bedrooms, this charming residence is a wonderful insight into the everyday life of Victorian Dublin.

His first play was *Widowers' Houses* (1892), and thereafter he wrote prolifically. Early plays such as *Arms and the Man* and *Candida* displayed intellectual wit, but his first real success was the American run of *The Devil's Disciple* (1897). In 1898, he married Charlotte Payne-Townshend, a rich Anglo-Irish Fabian who had nursed him through illness. In 1906, they moved to Ayot St Lawrence, Hertfordshire in England.

In 1904, King Edward VII laughed so much at *John Bull's Other Island* that he broke his seat at the Royal Court Theatre. Other triumphs at that London theatre were *Man and Superman* (1905), *Major Barbara* (1905) and *The Doctor's Dilemma* (1906). Shaw's *Pygmalion* (1914) was destined to have a second success as the musical comedy *My Fair Lady*.

The Nobel Prize in Literature 1925 was awarded to George Bernard Shaw, 'for his work which is marked by both idealism and humanity, its stimulating satire often being infused with a singular poetic beauty.'

Not many know that George Bernard Shaw was also a co-founder of the London School of Economics.

He is the only person to have been awarded both a Nobel Prize for Literature (1925) and an Oscar (1938), for his contributions to literature and for his work on the film *Pygmalion* (adaptation of his play of the same name), respectively. Shaw initially wanted to refuse his Nobel Prize outright because he had no desire for public honours.

The Longest Day

Another famous writer associated with the area is Cornelius Ryan (1920-1974) who was born on Heytesbury Street and served as an altar boy in Harrington Street church. He became a journalist and author, best known for his writings on popular military history, especially his best-selling Second World War books: *The Longest Day* (1959), *The Last Battle* (1966), and *A Bridge Too Far* (1974) which were subsequently made into hugely popular films.

Shaw writing in a notebook at the time of first production of his play Pygmalion. *(Courtesy of Portobello Historical Society)*

George Bernard Shaw, c. 1900. (Courtesy of Portobello Historical Society)

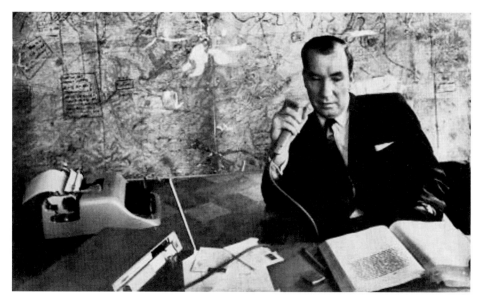

Cornelius Ryan, author of The Longest Day *(D Day, 6 June 1944) (1959),* A Bridge too Far *and* The Last Battle, *was born and raised in Heytesbury Street, Portobello. He always maintained that 'What I write about is not war but the courage of man'. (Courtesy of Simon & Schuster)*

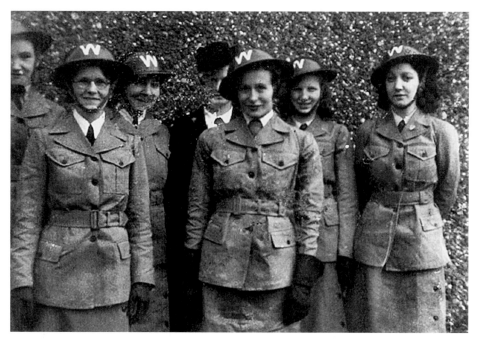

Evelyn Farrell from Lower Clanbrassil Street and local women in the Women's Auxiliary (the women's version of the LDF) during the Second World War. (Courtesy of Auld Decency/Dublin. ie Forums)

Æ

George William Russell (1867-1935), the writer and painter known as Æ, lived at 33 Emorville Avenue after his family moved to Dublin, and attended Dr Power's school in Harrington Street from 1878 to 1882. The first showing of his play *Deirdre*, in 1902, was at Harcourt Terrace.

Along the Banks of the Grand Canal

Paul Smith (1920–1997), writer, some of whose books (*The Countrywoman, Summer Sang in Me*, etc.) were set in tenements alongside the Grand Canal, was born close to Portobello Bridge. A stone plaque adjacent to Charlemont Bridge commemorates this great writer.

He left school at the age of eight, to drive a donkey that hauled a cart loaded with coal. He became involved with the Gate Theatre at sixteen years of age. In Ireland he worked as a costume maker and designer in the Abbey and Gate Theatres in Dublin. He went to London in the 1950s and then on to Sweden, where he started writing. He then moved to America and soon after to Australia, where he settled in Melbourne for some years. While there he wrote The Countrywoman (1962), The Stubborn Season (1962), and Stravanga (1963). He returned to Dublin in 1972 where he remained until he died on 11 January 1997. He was awarded the American Irish Foundation Literary Award in 1978, and was a member of Aosdána.

Smith's many travels took him all over the world, yet it was his tough early life that inspired The Countrywoman, the moving story of Mrs Baines as she struggled with the legacy of a brutal husband and poverty to raise her children. Anger, sadness and abiding humanity shape the narrative that lives through its lively dialogue. The heroine Mrs Baines emerges as a giant, a saint and a courageous mother who endures every test, until, 'Her eyes closed finally on the deep shadows. All care had indeed stopped.' He was a member of Aosdána, the affiliation of creative artists in Ireland.

George William Russell (1867-1935), the writer and painter known as AE, lived at 33 Emorville Avenue after his family moved to Dublin, and attended Dr Power's school in Harrington Street from 1878 to 1882. (Courtesy of Portobello Heritage Society)

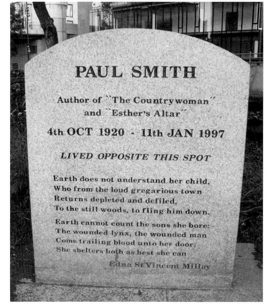

Memorial to Paul Smith (1920-1997), writer, along the banks of the Grand Canal, beside Charlemont Bridge. Some of his books (The Countrywoman, Summer Sang in Me, etc) were set in tenements alongside the Grand Canal. (Courtesy of Portobello Heritage Society)

Opposite, from top:

Slums at Charlemont Mall (beside Portobello Bridge) over-looking the Grand Canal, before the bulldozers moved in. (Courtesy of Gormangenealogy/Dublin.ie Forums)

A barge on the Grand Canal at Portobello, late 1950s. (Courtesy of the National Library of Ireland)

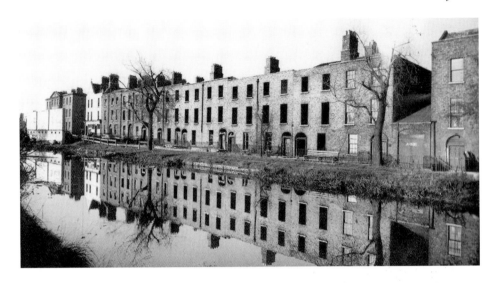

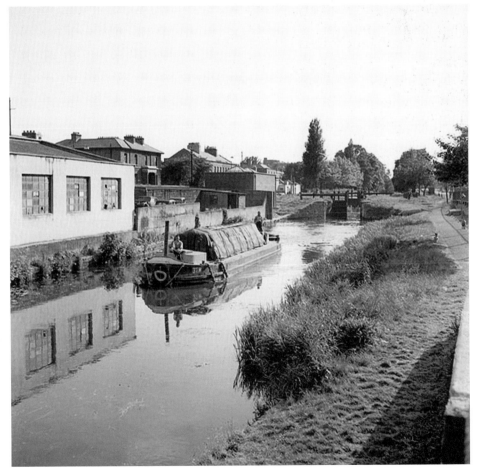

7

ARTISTS, ACTORS AND QUEEN VICTORIA

Not So Quiet Men

Barry Fitzgerald (1888-1961), the Abbey Theatre actor who was awarded an Oscar, and his brother Arthur Shields, Abbey actor, 1916 Volunteer and Hollywood actor, were born at Walworth Road.

Barry Fitzgerald (born William Joseph Shields) was a civil servant while also working at the Abbey Theatre. However, by 1929, he decided to turn to acting full-time. He was a close friend of playwright Sean O'Casey and starred in some of the latter's plays, *Juno and the Paycock* and *The Silver Tassie*.

In the early 1930s he went to Hollywood to star in another O'Casey work, *The Plough and the Stars* (1936), directed by the famous John Ford. This was followed by other Hollywood films including *The Long Voyage Home* (1940), *How Green Was My Valley* (1941), *And Then There Were None* (1945), *The Naked City* (1948), and *The Quiet Man* (1952) with John Wayne and Maureen O'Hara. Fitzgerald achieved a feat unmatched in the history of the Academy Awards: he was nominated for both the Best Actor Oscar and the Best Supporting Actor Oscar for the same performance, as Father Fitzgibbon in *Going My Way* (1944). Academy Award rules have since been changed to prevent this. He won the Best Supporting Actor Award. An avid golfer, he later broke the head off his Oscar statue while practicing his golf swing! He returned to live in Dublin in 1959.

Right: *Legendary Irish Oscar-winning and Abbey Theatre actor, Barry Fitzgerald (Will Shields), born in Walworth Road, Portobello. (Courtesy of Portobello Heritage Society)*

Below: *The plaque on wall of house at Walworth Road, Portobello, home of Barry Fitzgerald and his brother, Arthur Shields. (Courtesy of Dublin Tourism)*

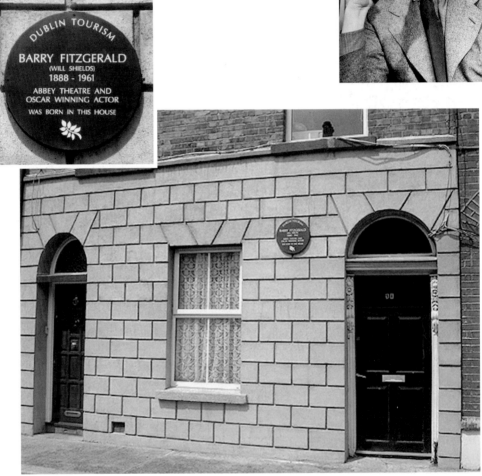

The home of Arthur Shields (15 February 1896-27 April 1970), the Irish stage and film actor. Born into an Irish Protestant family in Portobello, Dublin, he started acting in the Abbey Theatre when still a young man. He was the younger brother of actor Barry Fitzgerald (Will Shields), an Irish nationalist, who fought in the Easter Uprising of 1916. He was captured and was interned in Frongoch, North Wales. He afterwards returned to the Abbey Theatre. In 1936 John Ford brought him to the United States to act in a film version of The Plough and the Stars. He later returned to the US and for health reasons and decided to reside in California. He died at his home in Santa Barbara, California, aged seventy-four. (Courtesy of Portobello Heritage Society)

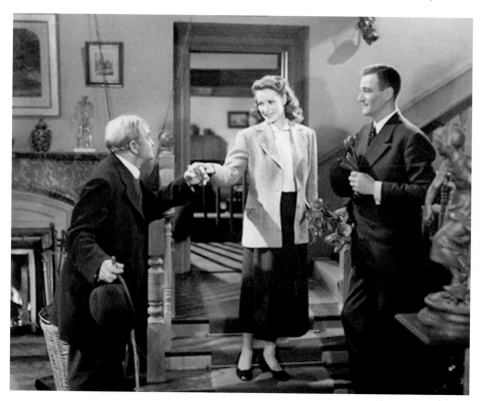

Above: *Walworth Road's (Portobello) Barry Fitzgerald with Maureen O'Hara and John Wayne in* The Quiet Man *(1952). (Courtesy of Portobello Heritage Society)*

ZOZIMUS
(MICHAEL MORAN)

PUBLISHED BY JOSEPH TULLY, 58 MIDDLE ABBEY-STREET, DUBLIN.
REGISTERED.
THE MOST FAMOUS OF DUBLIN BALLAD SINGERS
Died 1834.

Right: *Zozimus (Michael Moran), the blind ballad singer. (Courtesy of Auld Decency/Dublin.ie Forums)*

What a Life!

Eamonn Andrews (1922-1987), well-known radio and television presenter, was born on Synge Street, the same street as playwright George Bernard Shaw. He was educated at the local school, Synge Street CBS. He was as an amateur boxer and became a sports commentator on Radio Éireann. In 1950, he began presenting programmes for the BBC, being particularly well known for boxing commentaries, and soon became one of television's most popular presenters. However, he is best known as the presenter of the TV programme, *This Is Your Life*, from 1955 until his death in 1987.

He was chairman of the Radio Éireann Authority (now the RTÉ Authority) between 1960 and 1964, overseeing the introduction of State television to the Republic of Ireland and establishing the Irish State broadcaster as an independent semi-state body. He also owned the TV Club in Harcourt Street, famous for its bouncing dance floor.

Stamer Street Studio

Harry Kernoff (1900-1974) was an Irish painter who lived and had a studio under the roof of 13 Stamer Street. Born in London of Russian Jewish extraction, Kernoff moved to Dublin and became a leading figure in Irish modernism. Influenced by Seán Keating, Kernoff painted the Irish landscape, genre scenes, and portraits and is primarily remembered for his sympathetic interest in Dublin and its people. Some of his work includes the local scenery such as La Touche Bridge. He depicted street and pub scenes, as well as Dublin landmarks with sympathy and understanding. This is particularly evident in his woodcuts. While living in his adopted Dublin Jewish community of Portobello, he produced picture illustrations of his local scenes for a neighbourhood writer and friend, Nick Harris for his book called *Dublin's Little Jerusalem*.

In 1930, Kernoff visited the Soviet Union as part of an Irish delegation from the friends of Soviet Russia led by Hanna Sheehy-Skeffington. While visiting, he was influenced by the Association of Artists of Revolutionary

Right: *Eammon Andrews makes his way down to the track to congratulate Alec Lecroissette at Staines meeting in early 1950s. He is perhaps best known as the presenter of the UK's version of* This Is Your Life, *between its inception in 1955 and his death in 1987. (Courtesy of Portobello Heritage Society)*

Below: *Eamon Andrews at Staines Stadium, London, on 8 April 1955, commenting on a stock car race meeting. (Courtesy of Portobello Heritage Society)*

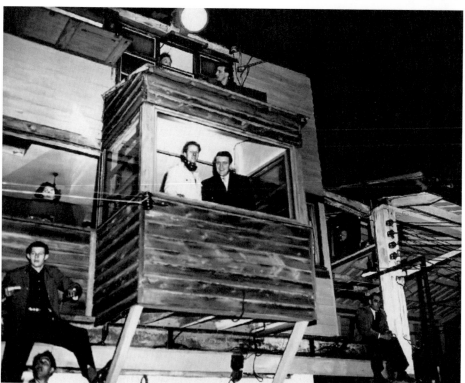

Russia. Kernoff is famously associated with Davy Byrne's pub, Duke Street, just off Grafton Street. His paintings and woodcuts of Davy Byrne's pub are documents of his friendship with the original owner.

Last Stand at Portobello

Jack Butler Yeats (1871-1957) lived for several years before his death in the nursing home at Portobello harbour. His last painting was completed just before his death.

John 'Jack' Butler Yeats was an Irish artist. His early style was that of an illustrator; he only began to work regularly in oils in 1906. His early pictures are simple lyrical depictions of landscapes and figures, predominantly from the west of Ireland – especially of his boyhood home of Sligo. His brother was William Butler Yeats, the Nobel Prize-winning poet. His father recognised that Jack was a far better painter than he, and also believed that, 'some day I will be remembered as the father of a great poet, and the poet is Jack'. One of his most famous paintings is 'The Liffey Swim'.

When he died, his great friend Samuel Beckett wrote that, 'Yeats is the great of our time ... he brings light as only the great dare to bring light to the issueless predicament of existence.' He is buried in Mount Jerome Cemetery.

Jack B. Yeats (1870-1957), Irish impressionist painter, and brother of poet William Butler Yeats. He spent his last years in the Portobello Nursing Home (Portobello College) overlooking the Grand Canal, where he painted his final sketch. (Courtesy of Hulton Archive/Getty Images)

The grave of Jack B. Yeats in Mount Jerome Cemetery, Harold's Cross. (Courtesy of Mount Jerome/Iain MacFarlaine)

Duel on the Late Late!

Dennis Franks (1902-1967), an actor of Polish-Jewish extraction, renowned for duelling with Ulick O'Connor on RTÉ's *Late Late Show* in the 1960s, lived at the beginning of South Circular Road, Portobello until his death on 14 October 1967.

Sing it Black! The famous Black family

Mary Black, Frances Black and their siblings grew up on Charlemont Street and attended music sessions in O'Connell's Pub of Richmond Street. They are a renowned musical family.

South Richmond Street's landmark O'Connell's pub. (Courtesy of Black&White Ireland/Portobello Heritage Society)

Queen Victoria Sent to Australia!

John Hughes (1865-1941), a notable Irish sculptor, lived in No. 28 Lennox Street. Probably his best-known work was a large statue of Queen Victoria, unveiled outside Leinster house by Edward VII in 1904. After Irish Independence the statue was stored at various locations before being given to the Australian government by the Irish government and it now stands outside the Queen Victoria Building in Sydney.

Sarah Purser

Sarah Purser had a studio in Harcourt Terrace for many years. She was born in Dún Laoghaire on 22 March 1848, the daughter of Benjamin Purser and Ann Mallet. They came to Dungarvan in the 1840s where her

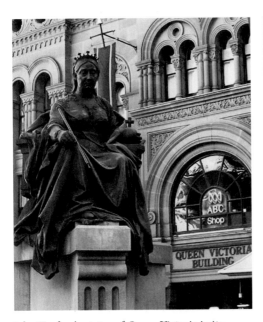

John Hughes's statue of Queen Victoria in its present location outside the Queen Victoria Building in Sydney. (Courtesy of Portobello Heritage Society)

Sarah Purser by John Butler Yeats.

father was involved in brewing and flour milling. At the age of thirteen, Sarah was sent to school in Switzerland for two years. She left Dungarvan in the summer of 1873 to make her living as a painter and settled in Dublin. There she trained in the Metropolitan School of Art and later went to the Academie Julian in Paris and also to Italy. She became a highly successful portrait painter and an important figure in the Irish art world at the turn of the century.

In 1903, she founded An Túr Gloine, the first Irish stained-glass studio. She was instrumental in drawing the attention of the art world to the works of John Yeats and Nathaniel Hone. She persuaded President W.T. Cosgrave to develop Charlemont House in Dublin's Parnell Square as a modern Art Gallery and also to house the Hugh Lane collection.

The Gate's a Wonder: Edwards and Mac Liammóir

Harcourt Terrace was also for many years the home of two of Dublin's best-known characters and highly talented actors, directors, dramatists, poets, impresarios, painters and founders of The Gate Theatre, Hilton Edwards and Micheál Mac Liammóir. According to Sheridan Morley in the *Sunday Times*, the Gate Theatre was one of the only truly great theatre companies Ireland has ever had. As they set about transforming the landscape of Irish theatre, they enlisted new and established talent in a roll call of personalities; Denis Johnston, Lennox Robinson, architect Michael Scott, Mary Manning, Padraic Colum, Ria Mooney, Sybil Thorndike, Christine and Edward Longford, and the blazing comet that was Orson Welles.

The Gate Theatre has been, artistically and architecturally, a landmark building for over 250 years. Established as a theatre company in 1928 by Hilton Edwards and Micheál Mac Liammóir, The Gate offered Dublin audiences an introduction to the world of European and American theatre and also to classics from the modern and Irish repertoire. It was with the Gate that Orson Welles, James Mason and Michael Gambon began their prodigious acting careers.

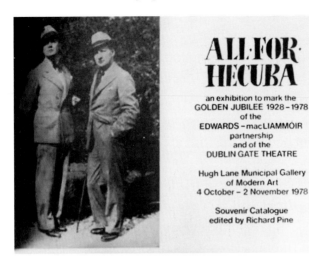

ALL·FOR·
HECUBA

an exhibition to mark the
GOLDEN JUBILEE 1928-1978
of the
EDWARDS – macLIAMMÓIR
partnership
and of the
DUBLIN GATE THEATRE

Hugh Lane Municipal Gallery
of Modern Art
4 October – 2 November 1978

Souvenir Catalogue
edited by Richard Pine

Cover of the souvenir catalogue, 1978, to mark the Edwards-MacLiammoir partnership and the Gate Theatre. They lived for many years at Harcourt Terrace, where a plaque was erected in their honour. (Courtesy of Gate Theatre)

The Parody King

The great pantomime actor, Cecil Sheridan (1910-1980), lived at 65 South Circular Road, and attended local Synge Street CBS. Cecil was famous for his performances in variety shows and pantomimes during a versatile career spanning over forty years. His performances in revues, variety shows, and pantomimes kept the spirit of the old music hall and vaudeville alive on the Dublin stage, well into the era of television. He was a familiar face Queen's Theatre and the old Theatre Royal, both in Dublin. He was also a regular at the Olympia Theatre, and was very active in raising funds for the theatre's restoration following the collapse of the proscenium arch in 1974. His clever use of wordplay earned him the title of 'Parody King'. Some of his memorable songs include 'Hannigan's Hooley' and 'Mick McGilligan's Daughter'.

8

A TALE OF TWO
PRESIDENTS

Chaim Herzog (33 Bloomfield Avenue) and Cearbhall O'Dalaigh (15 Portobello Road) were childhood friends. In 1985, Herzog visited Wesley College Dublin during his State visit to Ireland, during which he opened the Irish Jewish Museum in Portobello's Walworth Road. While visiting, he also unveiled a modern polished-steel Israeli sculpture, in honour of his childhood friend, Cearbhall Ó Dálaigh, the fifth President of Ireland in Sneem Culture Park, Co. Kerry.

Captain Jack White

Captain Jack White, DSO (1879-1946), co-founder of the Irish Citizen Army who fought on the Republican side in the Spanish Civil War lived at 19 Harrington Street while he was developing the Citizen Army from 1913.

And Three Lord Mayors!

John McCann (1905–1980) was born in Dublin and lived at 6 Lennox Street and was educated by the Christian Brothers of Synge Street. McCann worked as journalist and wrote plays for Radio Éireann and for

Left: *Captain Jack White, DSO (1879-1946), co-founder with James Connolly of the Irish Citizen Army that played a pivotal role in the 1916 Rising. He also fought in the Spanish Civil War. He lived at 19 Harrington Street while he was developing the Citizen Army from 1913. (Courtesy Portobello Heritage Society)*

Opposite, left to right:

Michael O'Riordan, founder of the Communist Party of Ireland, lived for many years in Victoria Street. (Courtesy of Portobello Heritage Society)

Michael O'Riordan wrote and article on Northern Ireland in this edition of Marxism Today *in 1973. (Courtesy of Cedar Lounge/ Wordpress)*

the Abbey Theatre. Some of his plays include *Give me a Bed of Roses, Early and Often, Blood Ii Thicker Than Water* and *Twenty Years a Wooing.* McCann stood unsuccessfully for election at the 1937 and 1938 general elections. He was first elected to Dáil Éireann as a Fianna Fáil TD at the Dublin South by-election held on 6 June 1939. The by-election was caused by the death of James Beckett of Fine Gael. McCann was re-elected at each general election until he lost his seat at the 1954 general election. He served as Lord Mayor of Dublin from 1947-48 and 1964-1965. He was the father of one of Ireland's greatest actors of the twentieth century, Donal McCann.

The Briscoe Family

Another Portobello resident was Abraham William Briscoe, the father of the first Jewish Lord Mayor of Dublin, Robert. The Briscoes became a prominent Dublin political family and lived on Emorville Avenue. The family first moved to the area as Russian immigrants.

Michael O'Riordan

Michael O'Riordan (1917-2006), who fought in the International Brigades during the Spanish Civil War and became head of the Communist Party of Ireland, lived for many years in Victoria Street.

Cearbhall Ó Dálaigh

Cearbhall Ó Dálaigh (1911-1978), fifth President of Ireland, lived much of his life in No. 15 Portobello Road.

Henry Robert Pigott

Henry Robert Pigott was born in 1838 at 16 Charlemont Street. He was one of an extended family of civil servants who had connections with St Patrick's Cathedral. He was living at 27 Lennox Street when he decided to become a Baptist missionary. He and his wife spent twenty-eight years ministering in Ceylon. Their son, Henry Pigott, was an Australian politician.

Maurice Levitas

Maurice Levitas (1917-2001), born in Portobello, was an anti-fascist who took part in the Battle of Cable Street and fought in the International Brigades during the Spanish Civil War. He is the father of Ruth Levitas.

Jack Murphy

Jack Murphy (1920-1984), trade unionist and politician, was born in 1920 at the back of Synge Street. He was elected to the Dáil in 1957 as the candidate of the Unemployed Protest Committee (UPC).

John Swift

John Swift was a resident of Clanbrassil Street from 1912 to 1936, where he formed many close bonds with Dublin's labour and Jewish communities. A lifelong socialist, trade unionist and secularist, Swift was General Secretary

(John) Jack Murphy (1920-1984) was an Irish politician and the first unemployed person ever elected to a national legislature. He was elected to Dáil Éireann as an independent Teachta Dála (TD) at the 1957 General Election for the Dublin South Central constituency. Jack Murphy was born in 1920 at the back of Synge Street, Dublin. (Courtesy of Portobello Heritage Society)

John Swift, 1896-1990

John Swift was a resident of Clanbrassil Street from 1912 to 1936. (Courtesy of Watchword Publications)

William Mulholland (1855-1935), a famous Irish-American dam civil engineer. He was the first superintendent and chief engineer of Los Angeles Department of Water and Power. He was brought up in underprivileged circumstances; his family could only afford to rent a house on Synge Street during his youth. (Courtesy of Portobello Heritage Society)

of the Irish Bakers' Confectioners' and Allied Workers' Amalgamated Union from 1943 to 1967. President in the mid-1940s of both the Dublin Trade Union Council and the Irish Trade Union Congress (ITUC), he also served as ITUC Treasurer from 1950 to 1958.

Philip Brady

Philip Brady (1893-1995) was owner of the well-known pharmacy at Kelly's Corner and the family house next door. He was a TD for twenty-six years up to 1977 and was a former Lord Mayor of the city. His son Gerard was also a TD and a cabinet minister.

9

CAROLINE'S GIG: A HIVE OF BUSINESS

There are many fine businesses past and present in the Portobello area. Some are no more, like The Pixie, famous for its Tipsy Cakes and Russian Slices. The Manhattan will revive memories for late-night revellers where May was renowned for her fast service – 'catch this'! Gigs Place, Caroline Records, The Bretzel, Lennox Café (previously Rutledge's Antiques), Tiesan Café, Mullen's Scrap Dealer, Gordon's Fuel Merchants, Anthony's Antiques, Kilbride's Pawnbrokers with its three brass balls, The Bunch of Grapes pub, Capital Mirrors, Peakins, dancing, bingo, and parties at the Garda Club on Harrington Street, the Curio Shop on Clanbrassil Street, Brady's Pharmacy at Kelly's Corner, all will resonate with many people.

The Hotel

Building the Grand Canal commenced in 1755 and in 1807 the depot for passenger traffic was established at Portobello, where a palatial hotel, subsequently a hospital and third-level college, was erected for the thousands of passengers, who, it was anticipated, would be constantly going and returning by the boats.

The original Portobello Hotel was opened in 1807 to serve the increasing number of users of the Grand Canal. It was also used as a hotel for

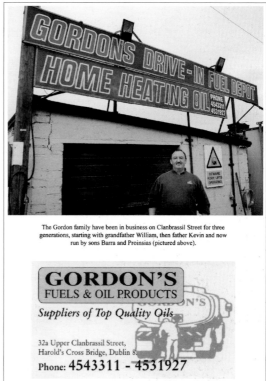

The Gordon family have been in business on Clanbrassil Street for three generations, starting with grandfather William, then father Kevin and now run by sons Barra and Proinsias (pictured above).

GORDON'S
FUELS & OIL PRODUCTS
Suppliers of Top Quality Oils

32a Upper Clanbrassil Street,
Harold's Cross Bridge, Dublin 8.
Phone: **4543311 - 4531927**

Above left: *Pat Egan, the great-great-grandson of the original owner, outside the Bunch of Grapes pub on Clanbrassil Street, before it was demolished. (Courtesy of 'Clanbrassil Street 1' by Sean Lynch and Holly O'Brien)*

Above right: *Gordon's fuel merchants at Upper Clanbrassil Street have been in business for many decades (some say centuries). They occupy a pivotal position on the banks of the Grand Canal. (Courtesy of 'Clanbrassil Street 1' by Sean Lynch and Holly O'Brien)*

Opposite, from top:

The long-established butcher's, Peakin, at Leonard's Corner. (Courtesy of 'Clanbrassil Street 1' by Sean Lynch and Holly O'Brien. Ken Lawford/ Paul Harris)

Caroline Records was a great rock music shop for vinyl records and tapes. Next door, at the Gigs Place, you could dine on scampi and whatever you liked until at least 4 a.m., on your way home from a night on the town. The Georgian and the Manhattan were also famous spots for dining in the area. (Courtesy of Damntheweather/Dublin.ie Forums)

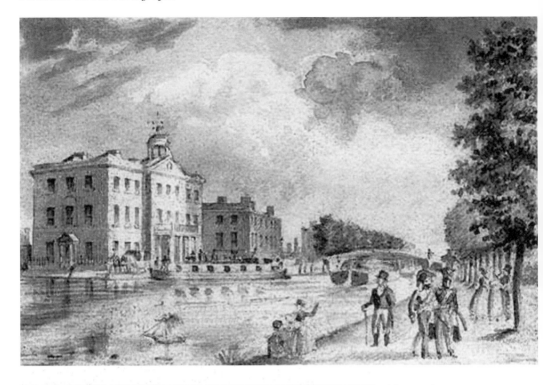

Above: *A painting of Portobello House and Grand Canal with Portobello Bridge, mid-nineteenth century. (Courtesy of the National Library of Ireland)*

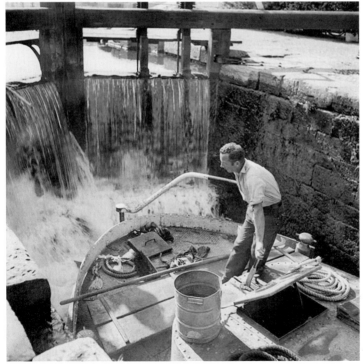

Left: *A barge going through the locks at Portobello Bridge in the late 1950s. (Courtesy of the National Library of Ireland)*

Right: *Late 1950s
scene along the Grand
Canal near Portobello.
(Courtesy of the
National Library of
Ireland)*

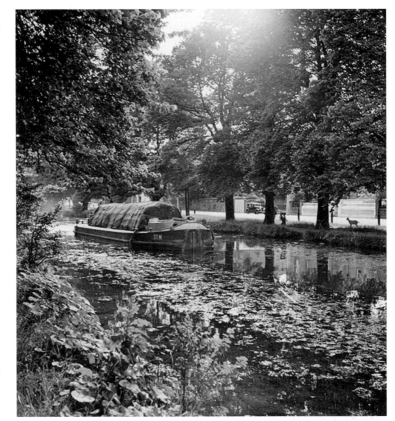

Below: *View of
Portobello Hotel
from across the
Grand Canal at Grove
Road. (Courtesy
Damntheweather/
Dublin.ie Forums)*

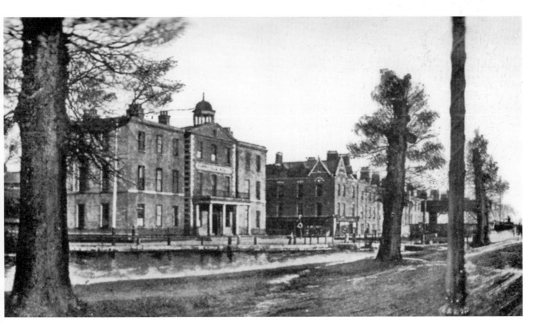

holiday-makers travelling along the Grand Canal from the midlands. In 1858, it was taken over by a Catholic order of nuns, who used it as an asylum for blind girls. Ten years later, it was sold to a Mr Isaac Cole, who renovated it and returned it to its original function as a hotel to accommodate 100 people. It was popular among the officers visiting the nearby Portobello Barracks. In the twentieth century the building became a nursing home. The Irish painter, Jack B. Yeats spent his last days in the care of the nursing home, as did Lord Longford of the Gate Theatre fame.

The Observatory

Thomas Grubb (1800-1878) developed his first telescope in a small house between Portobello Bridge and Charlemont Bridge. He founded the Grubb Telescope Company. One of his earliest instruments, the telescope for Markree Observatory in County Sligo, was, for several years, the largest telescope in the world. They provided the telescopes for many observatories worldwide, including Melbourne, Vienna and Aldershot Observatory in England in 1891. Subsequently he moved the growing business to nearby Rathmines to the appropriately named Observatory Lane.

The Old Bird of Portobello

In 1945, Christy Bird, the manager of a pawn shop on Charlemount Mall retired and immediately set up a furniture shop around the corner in South Richmond Street. He had moved to Dublin from Trim, Co. Meath, in 1908 to take up his apprenticeship. Little did he know, but he had set up what was to become one of Dublin's best-known antique and second-hand furniture shops. From that day Christy Bird & Co have been recycling Dubliner's furniture, be it household or antique. For many years, he furnished most of the early bed-sits, later flats, in the adjacent Flatland. In the Emergency years the bicycle was the only way to travel the streets of Dublin, and Christy Birds shop had the largest selection of used old black bikes in town.

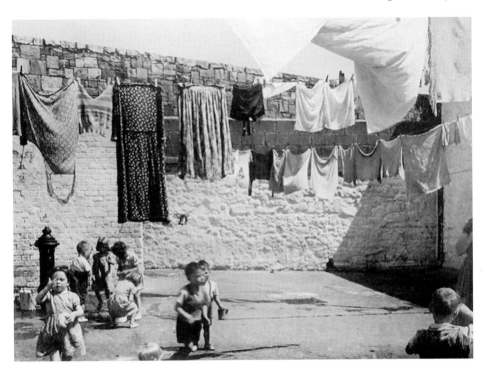

Children playing under the washing at Masterson's Lane (off Charlemont Street), 1952. Notice the water pump and bucket at left. (Courtesy of Polito45/Dublin.ie. Forums)

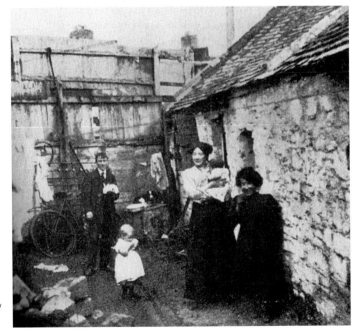

Photograph from the early 1900s of a tenement backyard in Faddle Alley (off Clanbrassil Street). (Courtesy of El Gronk/ Dublin.ie Forums)

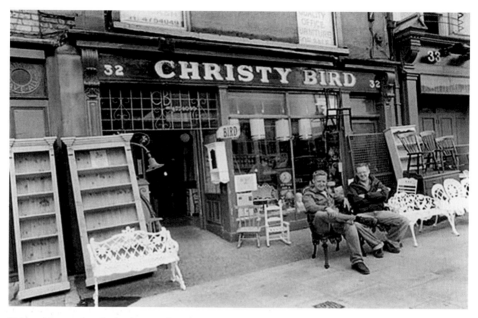

Taking it easy outside the famous furniture shop, Christy Bird's of South Richmond Street. (Courtesy of The Merry Ploug/Dublin.ie Forums)

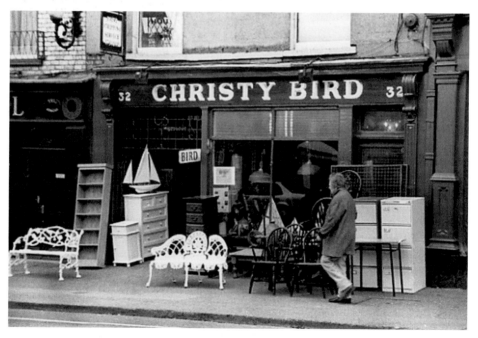

Christy Bird's antique/furniture shop on South Richmond Street. (Courtesy of Portobello Heritage Society)

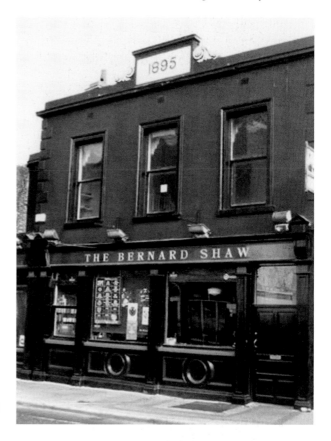

The Bernard Shaw pub, originally Bambrick's on South Richmond Street. The name was inspired by the nearby George Bernard Shaw birthplace in Synge Street. (Courtesy of Portobello Heritage Society)

Anybody who moved up to Dublin from the country, would go to Bird's for their transport.

Students from the nearby College of Surgeons who where finished with their human skeletons would sell them to Christy Bird's. 'We literally had skeletons in the basement,' recounted Christy Bird years later. He would then sell them back to the next batch of new students (the early days of re-cycling!)

Christy Bird & Co. has a long-established relationship with the arts. Many of Dublin's well-known theatre groups such as The Abbey and The Gaiety have hired props from the shop over the years. Films like *Saving Private Ryan, The Field, My Left Foot, Angela's Ashes, The Commitments, Cal,* and *Out of Africa* (winner of the Oscar for props), have all used furniture and props supplied from the shop. Customers get a great buzz to know

famous actor Liam Neeson used the chair they just bought in the film *Michael Collins* or the kitchen table they sold to Bird's had a starring role in RTÉ's soap, *Glenroe*.

South Richmond Street was and remains a bustling trading street from the time Christy opened his doors, with great pubs such as O'Connell's, the Bernard Shaw (formerly Bambrick's) and the Portobello, and several restaurants and cafes. In recent years it has developed a particularly attractive cosmopolitan atmosphere. Evidence is still there of shops which ceased trading, such as Wall & Keogh, Caroline Records, the Georgian Restaurant, and many more. The Aprile Café is still going strong, as is Gigs Place for late night (or early morning) revellers.

The Mogerleys

The Mogerley family (who were Mormons), manufacturers of meat products, lived and had their shop near Leonard's Corner, at 62 South Circular Road, Portobello. Maura Mogerley ran the shop. Her father, Heinrich Mogerley, who came to Ireland from Germany in 1908, founded the business.

The Bleeding Horse

'I saw him a few times in the Bleeding Horse in Camden Street with Boylan, the billsticker' (*Ulysses*, Chapter 16, Eumaeus episode, James Joyce).

Located on Camden Street and established in 1649, the Bleeding Horse is one of Dublin's most historic pubs and has been frequented over the years by literary greats such as Joyce, La Fanu, Gogarty and Dunleavy. The Bleeding Horse is reputed to be the second oldest pub in Dublin (The Brazen Head is the oldest), allegedly licensed in 1649. Writers such as Joyce, Oliver St. John Gogarty and John Elwood were familiar with this tavern. There are many stories on how the tavern got its name. The most frequent one told is that during the Battle of Rathmines, Cromwellian forces brought their

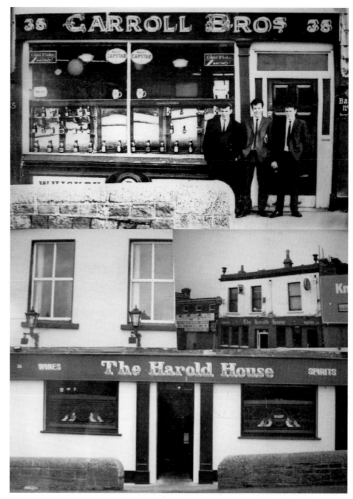

Collage of the Harold House pub, Upper Clanbrassil Street. (Courtesy of 'Clanbrassil Street 1' by Sean Lynch and Holly O'Brien. Ken Lawford/Paul Harris)

Right: *The Headline Bar at Leonard's Corner with its plaster or stucco front. Here you can see carefully composed consoles adorned with acanthus leaf ornament. Along with the stained glass, you can also see some ovolo and interlacing moulding and Grecian urns on and around the facade. (Courtesy of 'Clanbrassil Street 1' by Sean Lynch and Holly O'Brien)*

Below: *As part of a promotional campaign in the 1990s, Ken Lawford sent Nissan cars into the sky above his showrooms at Clanbrassil Street. (Courtesy of 'Clanbrassil Street' by Sean Lynch and Holly O'Brien)*

wounded horses to the thatched, timber inn that stood here. From the early 1970s to the early 1990s, it was called the Falcon Inn.

Other popular pubs in the area include the Portobello Hotel (on the site of the old Davy's Pub), the George Bernard Shaw, O'Connell's Pub, The Barge, the Ryan's Lower Deck, Cassidy's, the Headline, the Café Leonard, the Harold House, the Man of Achill and Francis McKenna's.

President Bill Clinton's Cassidy's

Cassidy's Bar, established in 1856, was once the home of the *Freeman's Journal*, the oldest national newspaper in Ireland that harboured some of the leaders of the 1916 rising. Renowned for Bill Clinton's visit in 1995. Cassidy's is owned and run by Bill's cousins.

The pub has changed little from the original Victorian pub. The family was a branch of Delahunt's, a family of grocers and spirit merchants who had owned a number of businesses on Camden Street in the 1890s. The Delahunt' was immortalised by James Joyce in *Ulysses*, where Lenchan remarks, 'Delahunt of Camden Street had the catering and yours truly was chief bottle washer ... Lashings of stuff we put up, port wine, sherry and curacao to which we did ample justice.'

Today, Cassidy's is a cosmopolitan yet traditional pub attracting tourists, city shoppers and business people alike.

According to the *Sunday World's* Pub Spy:

> ... for those of us pious in the way of porter, pilgrims for whom joy itself is to worship at a genuine shrine to stout, a blessed basilica of booze, then Mecca – the holiest site of our faith – is to be found on a sacred corner of Dublin's Camden Street. Housed in a lovely old 1780s residence, an evocative triumph of ancient wood and half-lit atmospherics, sits the timeless temple known as Cassidy's.

Jack Carvill's

Carvill's off licence is a long-standing family business with a reputation for excellence in their trade. The shop dates from 1905, and still retains most off its original fittings. It even got a mention in *Ulysses*. Apart from looking great, Jack Carvill's stocks a really wide range of beers and has a huge wine selection.

And finally, Café Leonard, at Leonard's Corner, the pub with two addresses; one side has a Clanbrassil Street address and the other has a South Circular Road address! Now, if trying to figure that out would not give a hangover, I don't know what would.

FURTHER READING

Boylan, H., *A Dictionary of Irish Biography* (Gill & Macmillan: Dublin, 1999).

Casey, C., *Dublin: The City Within the Grand and Royal Canals and the Circular Road with the Phoenix Park* (Yale University Press: Yale, 2005).

Curtis, M., *Rathmines* (The History Press Ireland: Dublin, 2011).

Daly, M., *Dublin's Victorian Houses* (1998).

Donnelly, N., *History of the Parishes of Dublin Part 6* (1908).

Elrington Ball, F., *A History of the County Dublin* (1903).

Fitzpatrick, S. & Ossory, A. *Dublin: A Historical and Topographical Account of the City* (Metheun: London, 1907).

Harris, N., *Dublin's Little Jerusalem* (A&A Farmar: Dublin, 2002).

Keogh, D., *Jews in Twentieth-Century Ireland* (Cork University Press: Cork, 1998).

Lynch, S.,& O'Brien, H., *Clanbrassil Street, Past and Present History* (2009).

McCready, Revd C.T., *Dublin Street Names Dated and Explained* (1892).

Rivlin, R., *Jewish Ireland* (The History Press Ireland: Dublin, 2011).

Showers, B.J., *The Bleeding Horse and Other Ghost Stories* (Mercia Press: Cork, 2008).

Somerville-Large, P., *Dublin: The First Thousand Years* (Appletree Press: Belfast, 1988).

Taylor, M., *17 Martin Street* (O'Brien Press: Dublin, 2008).